POSTCARD HISTORY SERIES

Flagstaff

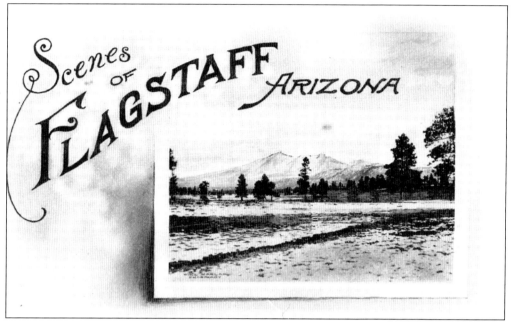

ALBERTYPE POSTCARD, C. 1930S–1940S, PUBLISHED BY MARLAR DRUG COMPANY. Often, postcards were sold as a thematic souvenir book or as packets consisting of 10 or more postcards. This postcard was the cover of a Flagstaff-themed pack.

ON THE FRONT COVER: This Albertype, hand-colored postcard depicts a scene during the late 1930s on Route 66 through downtown Flagstaff. This street has been changed to many different names over the years. First it was known as Front Street, then Railroad Avenue, and later it became part of the National Old Trails Highway, followed by Route 66. Today, it is known as Route 66 or Santa Fe Avenue. (Author's collection.)

ON THE BACK COVER: Postmarked July 14, 1912, from Flagstaff, this divided back postcard displays the view looking northwest toward the San Francisco Peaks. Written on the back of the postcard is the following: "This is the first postal I have directed since I have been here. These peaks are the first thing I see in the morning. Still yours, Rachel." Today, this area is very well developed into a community of Flagstaff known as Coconino Estates. (Author's collection.)

POSTCARD HISTORY SERIES

Flagstaff

John G. DeGraff III

ARCADIA
PUBLISHING

Published by Arcadia Publishing
Charleston, South Carolina

Printed in the United States of America

Library of Congress Control Number: 2011939320

For all general information contact Arcadia Publishing at:
Telephone 843-853-2070
Fax 843-853-0044
E-mail sales@arcadiapublishing.com
For customer service and orders:
Toll-Free 1-888-313-2665

Visit us on the Internet at www.arcadiapublishing.com

*To the wonderful people of Flagstaff, who have helped to promote and share
their love for this beautiful community.*

Contents

ACKNOWLEDGMENTS

There are certain individuals I would like to thank for helping me put together this collaboration of postcards. John Lutz is responsible for scanning and preparing the postcard images. His knowledge of the art of scanning saved me precious time. James E. Babbitt helped me to pursue this book and allowed me under his wing with our book, Images of America: *Flagstaff*, also published through Arcadia Publishing. It helped open the doors and allowed me to be able to share more of my collection. He was also there for advice and suggestions. I would like to thank Joe M. Meeham, curator at the Arizona Historical Society Pioneer Museum, for taking the time to go over the text for this publication. I would also like to take this opportunity to tell my wife, Kelly, and my kids, Garrett and Wesley, that I appreciate them allowing me the time and space to pursue this project. Finally, I would like to thank Stacia Bannerman and Arcadia Publishing for making this book possible. They have been very helpful in this whole process.

My interest and love for this wonderful town was initiated by my time as an employee of the Weatherford Hotel. Owners Sam Green and Henry Taylor, along with general manager Matt Bial, opened my eyes to the rich, interesting history of Flagstaff. The owners of the hotel have done an incredible job preserving, displaying, and restoring historical elements of Flagstaff that inspired me to start collecting my own piece of Flagstaff history.

All images in the book are from my personal collection unless noted otherwise.

INTRODUCTION

The year is 1918. It is the middle of summer, and you have been driving for hours through the barren desert on a bumpy road with temperatures in the 100s. You see your destination ahead of you, 50 miles away. It's a mountain springing up in the middle of nowhere, with pockets of snow still crowning the top. Getting closer, you notice piñon and ponderosa trees surrounding you . . . and the fresh scent of cool, pine-scented, mountain air. It's getting late in the day, and you realize you need to find a place to stay for the night before heading any farther. The town of Flagstaff is just ahead, and you know there is a place to rest there. After finding lodging, you stop off at a store to pick up some necessities, and you notice the postcard rack. There are dozens to choose from. You focus on your favorite one, go back to your room, get ready for bed, and start writing. You write a letter back home to your mother to let her know you're okay and to describe the wonderful views and discoveries you experienced today.

This situation was an everyday occurrence for thousands of travelers each year who were exploring this part of the country. This book contains postcards that depict what Flagstaff and its surrounding areas once looked like. Also included are some writings from visitors to the area. There was much thought and effort associated with these letters accompanied by their eloquent handwriting. Many have postmarks and the exact date they were sent.

Deltiology is the formal name for postcard collecting and is currently the third-largest collectable hobby in the world, behind stamps and coins. This volume was created to display all the different aspects of Flagstaff that people loved and wanted to share. The majestic San Francisco Peaks greeted early visitors to Flagstaff. Most who visit this town usually were in transit—venturing to the Grand Canyon, passing through on their way to California, or just getting out of the heat of the surrounding desert. Many came to this part of the country to explore all that Northern Arizona had to offer. Visiting the Navajo Indian Reservation was on everyone's list of things to do. Visitors wanted to understand its culture and take home a handmade craft. Recreation was another reason for their visit. Hunting and fishing were very popular along places like Oak Creek Canyon, Mormon Lake, and Lake Mary. Camping in the comfortable climate of the ponderosa pines was on some agendas. Just a leisurely drive through the forest was enjoyable for many. Some travelers made the journey to visit national and state parks like Grand Canyon, Walnut Canyon, or Sunset Crater. Winter activities at Arizona Snowbowl and in town attracted folks, too.

Many of the postcards that were sent from Flagstaff were not just of landscapes, but also of structures, businesses, churches, and schools. Some postcards that were mailed were from people living in Flagstaff. They wanted to show where they worked and lived. Very popular cards were bird's-eye views of the town from atop Observation Mesa (now Mars Hill). Many

cards were of the Santa Fe Railroad and lumber companies. These industries were the backbone of Flagstaff at the time and were the reason for its existence. Northern Arizona Normal School was a popular postcard subject as well. Old Main has a certain grandeur that students and fellow citizens liked to show off. This structure, along with the Coconino County Courthouse, Weatherford Hotel, and some churches, were made from local red Moenkopi sandstone. The red sandstone not only looked beautiful in person and on postcards, but it could withstand fires that have frequented the town.

Postcards are usually classified by the era in which they were produced. The following classifications are denoted in the book, along with the postmark, if the postcard had been used. Undivided Back postcards usually were described as having a blank back where all the space was used for the address. The messages were written on the front of the card. They were used from 1901 through 1907. Divided Back postcards were divided up into two sections on the back. One side was used for the message, and the other side was used for the address. These postcards were used from 1907 to 1915. White Border postcards were usually printed with white borders around the picture. They were mainly produced from about 1915 to the 1930s. The paper stock was coated with a non-glossy surface. From the 1930s to the early 1950s, many postcards were known as Linen postcards. Most of the views on the cards were printed on card stock that had a linen texture. Around the same time, Real-Photo cards were also used. These cards were printed on photographic paper with a postcard back. Eastman Kodak developed a camera for this purpose, which was affordable and very desirable. The public was able to take black and white photographs and have them printed onto postcards. The cameras even had tools that came with them that enabled one to write a message right onto the negative. Carson was a popular company in town that utilized this technology for its postcards. Finally, there are Photo-Chrome cards, which were color photographs turned into "glossy" postcards. They first started being produced in the 1940s and are still being used today.

The postcards used in this book had many common printers and publishers. The two most popular companies used in Flagstaff were the Albertype Company and the Curt Teich Company. The Albertype Company operated from 1890 to 1952 and was based out of Brooklyn, New York. They used a printing application named collotype. It was cheap and had the ability to reproduce prints fairly accurately. The companies in Flagstaff that used the Albertype Company to print their postcards were Will Marlar Pharmacy, B. Hock News Depot, City Drug Store, Stillwell's News Service, Brown's News Stand, The News Stand, and Robertson's News Stand. Another printer used in Flagstaff was the Curt Teich Company. They were in business from 1893 to 1978. Their postcards utilized offset lithography and printed colored images on linen textured paper. They printed more postcards than any other printer in the United States. The Flagstaff companies that used them to print their images were the Babbitt Brothers Trading Company and The Hunter Drug Company. Verkamp's General Store, situated at the Grand Canyon, also used their services.

The author has tried to incorporate some of the original messages written on the postcards in this book. Some postcard captions will describe what is printed on the back of the postcard. Other postcards will be followed by historical tidbits about the topic at hand. Although this book contains numerous Flagstaff postcards, it only scrapes the surface of all the postcards there are of this wonderful town. The postcards in this book have been acquired from all over the world. Very few have been found in Flagstaff. Many other postcards can be viewed in Arcadia Publishing's Images of America: *Flagstaff*, coauthored with James E. Babbitt.

One

THE PEAKS

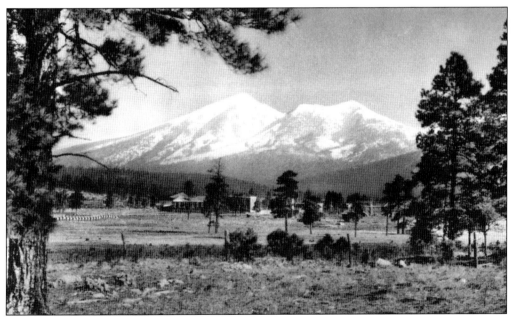

ALBERTYPE POSTCARD, C. 1920S–1930S, PUBLISHED FOR STILLWELL'S NEWS SERVICE.
In the early 17th century, a mission group at Oraibi, on the Hopi Indian Reservation, came up with the name San Francisco Peaks in memory of St. Francis of Assisi, the founder of their order. The San Francisco Peaks consist of six peaks that are very visible from most everywhere in Flagstaff and its surrounding areas. Humphreys Peak, with an altitude of 12,633 feet, is the highest point in the state. It was named to honor Andrew Atkinson Humphreys, a surveyor for railroad routes and wagon roads.

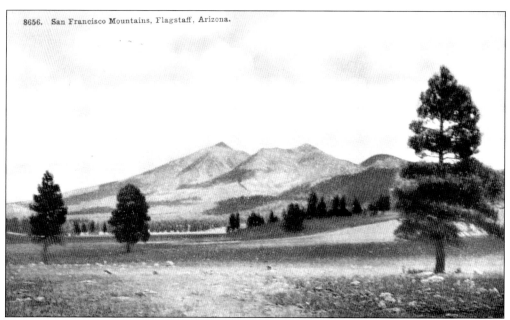

DIVIDED BACK POSTCARD, 1915 POSTMARK. The second-tallest peak is Agassiz Peak. At an elevation of 12,340 feet, it is often mistaken for Humphreys Peak. This peak was named after Jean Louis Rodolphe Agassiz, a Swiss geologist who helped survey for the railroad as well. He is noted as the first person to consider the peaks to be an extinct volcano.

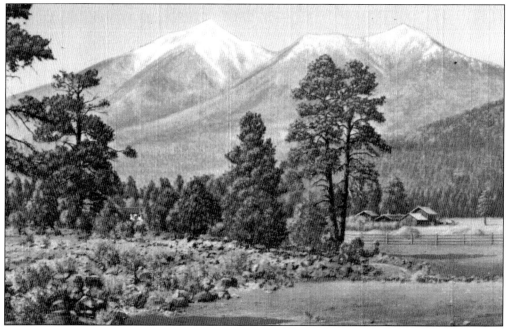

CURT TEICH LINEN POSTCARD, 1945 POSTMARK. Sitting to the east of Agassiz Peak is Fremont Peak (altitude 11,940 feet). It was named after the governor of the Arizona Territory, John Charles Fremont. Doyle Peak (altitude 11,400 feet) is situated at the east end and is named after Allen Doyle, a well-known cattleman and guide in the area. The other two peaks are Aubineau (altitude 11,838 feet) and Rees Peak (altitude 11,474 feet).

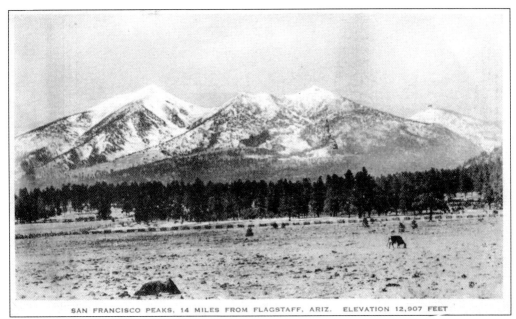

SAN FRANCISCO PEAKS, 14 MILES FROM FLAGSTAFF, ARIZ. ELEVATION 12,907 FEET

ALBERTYPE POSTCARD, 1932 POSTMARK, PUBLISHED BY THE NEWS STAND. Another popular name for the San Francisco Peaks is the Spanish phrase *Sierra sin Agua* (mountains without water). Many cultures have their own name for the peaks. In Navajo, they are called *Dook'o'ooslííd* (abalone shell mountain); in Hopi, *Nuva'tuk-iya-ovi* (the place of snow on the very top); and in Havasupai, *Hvehasahpatch* (big rock mountain).

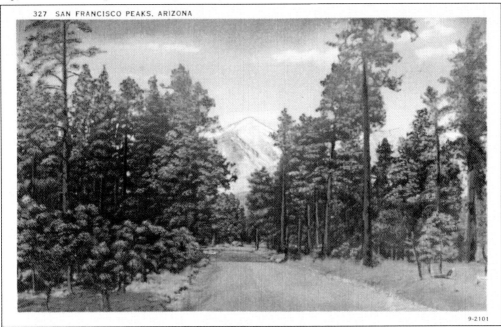

327 SAN FRANCISCO PEAKS. ARIZONA

9-2101

LINEN POSTCARD, C. 1930S–1940S, PUBLISHED BY HERZ POST CARDS. The writing on this card claims, "The City of San Francisco, California can be seen on a clear day from its summit, this is why the explorers called it San Francisco Peaks." While this statement is false, many people have believed it to be true.

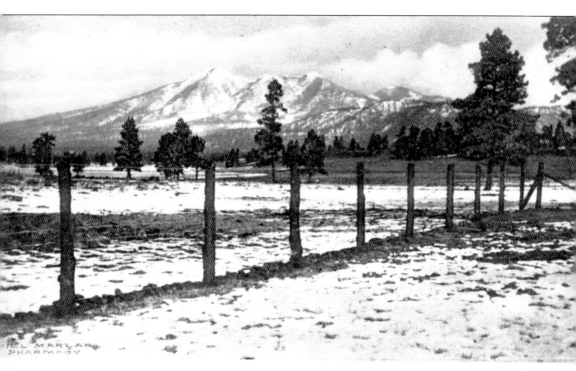

THE SAN FRANCISCO PEAKS BY MOONLIGHT, NEAR FLAGSTAFF, ARIZONA.

ALBERTYPE POSTCARD, C. 1910S–1920S, PUBLISHED BY WILL MARLAR PHARMACY.
Native Americans consider these peaks to be a very spiritual place. The Hopi cherish the San Francisco Peaks because they are home to the Kachina Spirits. These kachinas can represent almost anything in the natural world, such as a natural phenomenon, a concept, or a quality. The Hopi made dolls that represent these spirits. The Navajo consider the peaks one of their four sacred mountains. The other three are Mount Taylor in northwest New Mexico, and Blanca Peak and Hesperus Peak in southern Colorado. All four mountains mark the boundaries of the Navajo homeland. The San Francisco Peaks can be seen as far as 100 miles away in almost every direction. Certain plants and animals found on these peaks play an important role in the lives of many of these cultures.

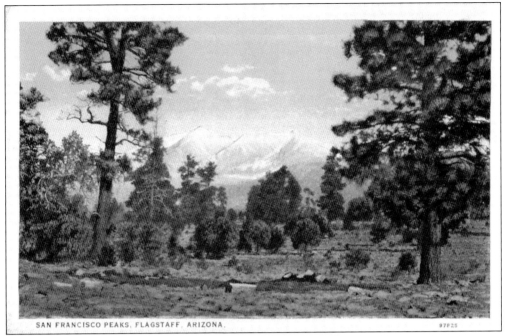

SAN FRANCISCO PEAKS, FLAGSTAFF, ARIZONA. 97P25

CURT TEICH POSTCARD, C. 1930S, PUBLISHED BY BABBITT BROTHERS TRADING COMPANY. The San Francisco Peaks were actually, at one time, one enormous peak that rose over 16,000 feet. This strato-volcano was created between 2,000,000 and 400,000 years ago. A gigantic eruption blew the top off the volcano. Glaciation and erosion have also helped to create the view seen today.

CURT TEICH LINEN POSTCARD, 1941 POSTMARK, DISTRIBUTED BY J.R. WILLIS. The message on the reverse of this postcard reads as follows: "View returning from Williams and Flagstaff. Having lots of rain here. We are so high up the lightening [*sic*] seems to crackle around our ears. Mountains are beautiful. Folks much better and we are having a nice visit. We are to be entertained on a ranch to-morrow. Chas and Stella."

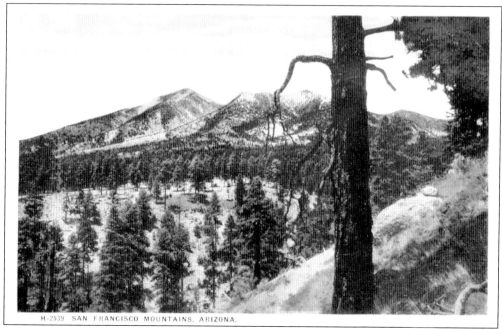

H-2539 SAN FRANCISCO MOUNTAINS, ARIZONA.

DIVIDED BACK POSTCARD, 1924 POSTMARK. A biologist by the name of Clinton Hart Merriam studied the San Francisco Peaks in 1889. Merriam came up with a way to describe certain "life zones" to explain the relationship between elevation and types of vegetation. These climate zones include Lower Sonoran, Upper Sonoran, Transition, Canadian, Hudsonian, Timberline, and Arctic-Alpine Tundra. Merriam considered these zones to mirror the rest of the world.

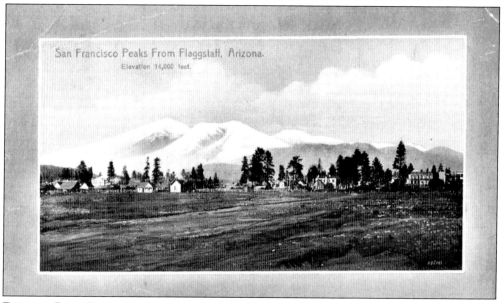

DIVIDED BACK POSTCARD, 1910 POSTMARK. The Arctic-Alpine Tundra on the San Francisco Peaks is the second-most-southerly tundra in the United States. There are some plants with special adaptations that can only be found here, such as the endangered San Francisco Peaks groundsel. The distance required to travel between the two extremes of Alpine Tundra at the top to Sonoran Desert at the base is one of the shortest in the world.

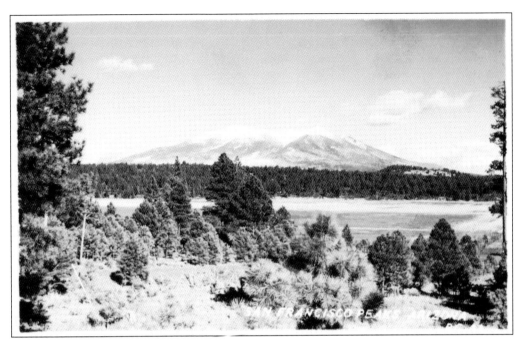

ABOVE: REAL-PHOTO POSTCARD, 1944 WRITTEN DATE; BELOW: REAL-PHOTO POSTCARD, C. 1930S–1940S. The San Francisco Peaks have a tremendous impact on weather conditions in Flagstaff. The western slopes of the peaks (shown above) tend to receive more precipitation. This leads to more vegetation and greater diversity of plant life. In the eastern portion of the peaks (shown below), precipitation is greatly reduced, creating high desert conditions. Storms passing through get their moisture squeezed out at the higher elevations and leave very little to be spread on the other side.

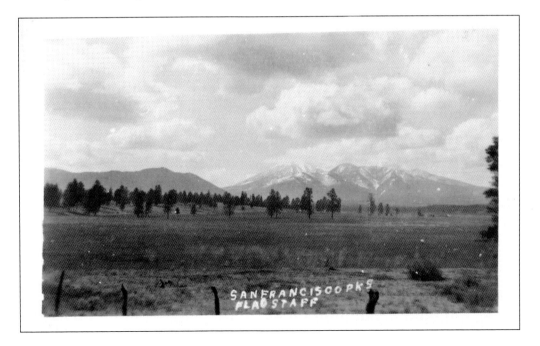

REAL-PHOTO CARSON POSTCARD, 1938 POSTMARK. Forests surrounding the Flagstaff area originally consisted of sporadic stands of pine trees. Natural fires, usually created by lightning, would consume the forest floor, ridding it of grasses, needles, and smaller trees, and creating a healthier forest. Today, the forests are much denser with young trees due to fire suppression. In turn, forest fires are likely to be more catastrophic. "Prescribed" or "controlled" burns are a technique used today in managing the forest to prevent large-scale forest fires and promote a healthier forest.

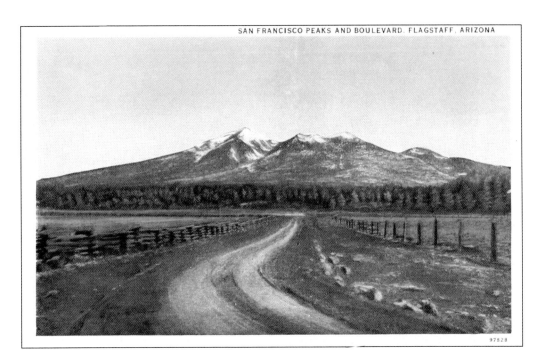

ABOVE: CURT TEICH POSTCARD, C. 1930S, PUBLISHED BY BABBITT BROTHERS TRADING CO.; BELOW: REAL-PHOTO CARSON POSTCARD, C. 1930S. Both postcards show the road heading northwest out of town. Known as Fort Valley Road, it leads to San Francisco Scenic Mountain Boulevard, Snowbowl Road, the Grand Canyon, a few farms, and some ranches. It is also known as US Highway 180. This east-west route runs from Weatherford, Texas to Valle, Arizona covering a distance of 1,092 miles. The original route was designated in 1926 and ran from Weatherford to El Paso, Texas. It was extended west to Valle in 1961.

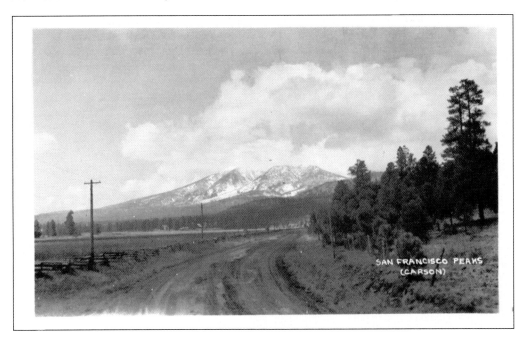

San Francisco Peaks, Flagstaff, Ariz.

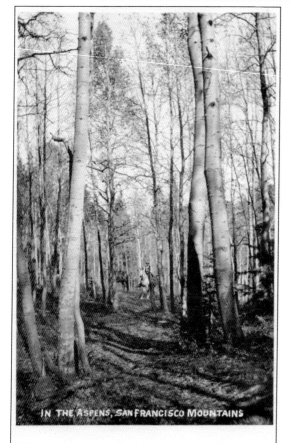

IN THE ASPENS, SAN FRANCISCO MOUNTAINS

DIVIDED BACK POSTCARD, 1923 POSTMARK. The message on the reverse reads, "Dear Mother: Will see the Grand Canyon of the Colorado this P.M. You might send about twenty-five dollars to Uncle Andrew. I fear I may need it. Please take good care of yourself. With Love, Son."

DIVIDED BACK POSTCARD, 1909 POSTMARK. The message on the reverse of this card says, "Dear Sister: Eugene arrived right side up and is having a pretty good time hunting squirrels with my brother. I wish you could have come too. Eugene's first day here he was so homesick but is all right now though. With much love, Marie."

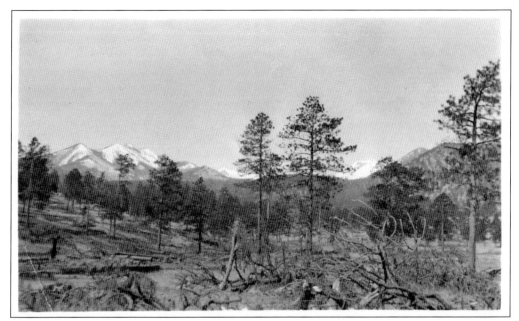

REAL-PHOTO POSTCARD, 1918 POSTMARK. The description written on the back of the postcard describes this as a point 15 miles from Flagstaff on the Grand Canyon road. Traveling to the Grand Canyon usually took about five to six hours, and sometimes much longer. Many tourists utilized the stagecoach lines that left from Flagstaff to reach the Grand Canyon. Today, on paved roads, it takes about an hour and a half to reach the rim.

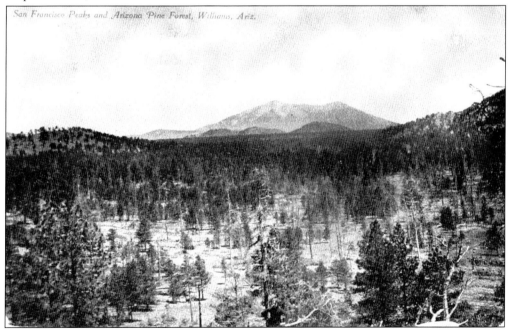

DIVIDED BACK POSTCARD, 1907 POSTMARK. Flagstaff is home to the world's largest contiguous ponderosa pine forest. The view in this postcard was taken from Williams, Arizona. The letter on the back reads, "Am having a great time—just starting for Grand Canyon. This is a great place. Nothing to see at all. Hope you are well. Nam."

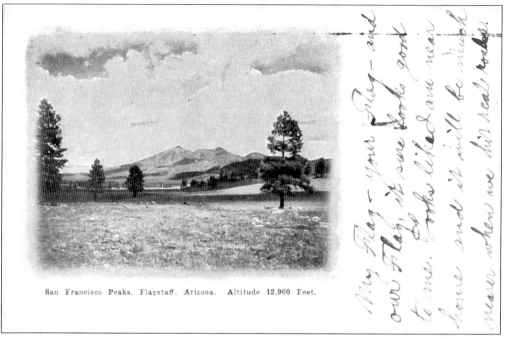

San Francisco Peaks, Flagstaff, Arizona. Altitude 12,960 Feet.

DIVIDED BACK POSTCARD, 1907 POSTMARK. The message on this postcard reads as follows: "My Flag—your Flag—and our Flag, it sure looks good to me. Looks like I am near home and it will be much nearer when we hit real roads. Some rain with some cold. Roads bad as a whole. Hope for better. East going cars report big rain. Paul's six leg car runs most of the time on 3 and 4 legs. Otto."

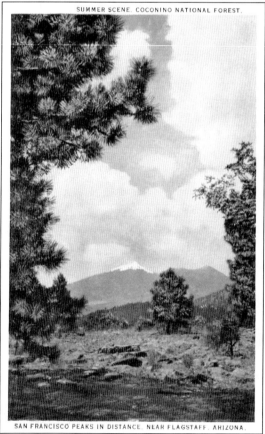

SUMMER SCENE, COCONINO NATIONAL FOREST.

SAN FRANCISCO PEAKS IN DISTANCE, NEAR FLAGSTAFF, ARIZONA.

CURT TEICH POSTCARD, C. 1920S–1930S, PUBLISHED BY BABBITT BROTHERS TRADING COMPANY. This postcard's description reads, "Flagstaff area offers more natural settings for artists, authors, etc., than any section of the United States." Today, Flagstaff is still renowned for its local artists. Many take inspiration from the San Francisco Peaks.

Two

LUMBER

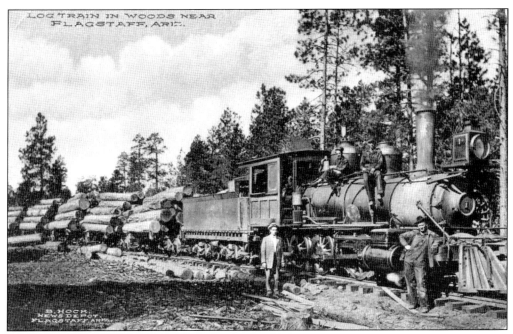

ALBERTYPE POSTCARD, C. 1910S–1920S, PUBLISHED BY B. HOCK NEWS DEPOT. This postcard shows four railroad workers posing in front of their log train, which was probably headed to the mill to unload. The ponderosa forests surrounding Flagstaff were timbered initially to help build the railroad. The logs were taken to the mill to make more railroad ties. The relationship between the railroad and the lumber industry in the Flagstaff area was instrumental in the foundation of Flagstaff's early history.

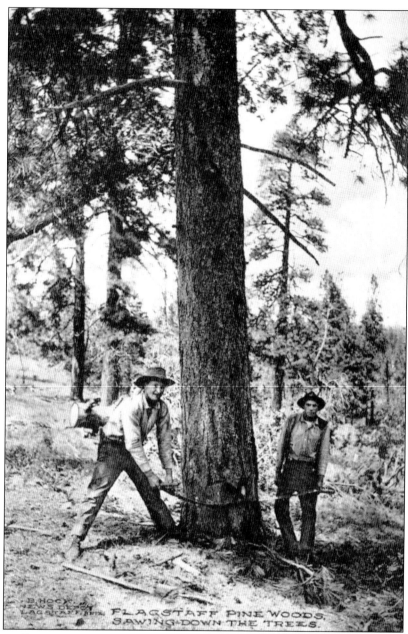

ALBERTYPE POSTCARD, 1917 POSTMARK, PUBLISHED BY B. HOCK NEWS DEPOT. In 1882, with the arrival of the Atlantic and Pacific Railroad, the logging industry started with owner E.E. Ayer opening Flagstaff's first large mill on August 19. About 1884, Ayer hired Denis Mathew (D.M.) Riordan as the mill's general manager and ended up selling the mill to him in 1887. Riordan had his brothers, Michael and Timothy, help manage the mill. The name of the mill changed to the Arizona Lumber Company. Within a few weeks of their purchase, the mill burned down. The brothers rebuilt a bigger and better one. In 1893, D.M. sold his share of the company to Timothy, Michael, and Fred W. Sisson. The business was then known as the Arizona Lumber and Timber Company. The mill ran until 1930, when the Great Depression affected business and caused it to shut down.

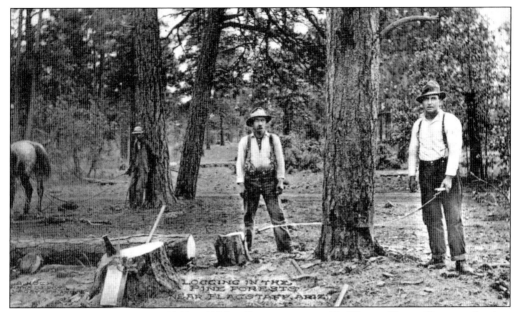

ALBERTYPE POSTCARD, C. 1910S–1920S, PUBLISHED BY B. HOCK NEWS DEPOT. Sawing down trees was a tough and backbreaking job. The cut from the saw had to be below a certain height off the ground. The Forest Service would enforce this rule. The fallen tree was stripped of its branches and then had to be cut into the proper sized lengths. This was to make the logs into manageable lengths and also was required by the mill to reduce the amount of waste during the milling process.

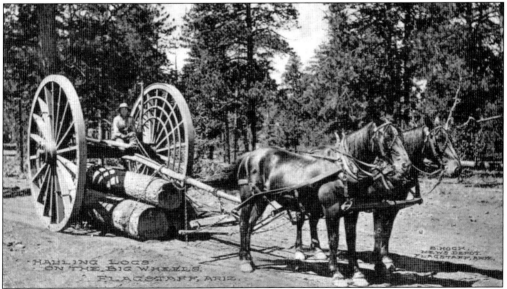

ALBERTYPE POSTCARD, C. 1910S–1920S, PUBLISHED BY B. HOCK NEWS DEPOT. After the trees were felled and cut, these "Big Wheels" were backed over the logs. The tongue of the cart was raised and chains were placed under the logs, then attached to hooks on top of the axle. As the tongue was brought down, it lifted the logs off the ground. Chains were wrapped around the front of the logs and attached to the tongue. The horses then were harnessed to the cart, and the logs were pulled to awaiting railcars or trucks.

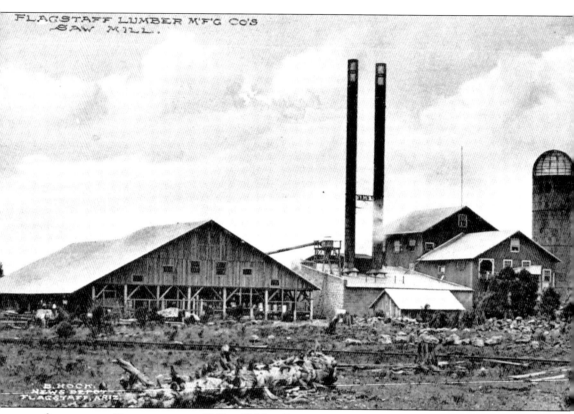

ALBERTYPE POSTCARD, C. 1910S–1920S, PUBLISHED BY B. HOCK NEWS DEPOT. The Flagstaff Lumber Manufacturing Company began operations in November 1910. It was the second large mill in Flagstaff, behind the Riordans' Arizona Lumber and Timber Company. Edward T. McGonigle, an employee of the Riordans for 20 years, helped get the business started along with Joe Dolan and got financial assistance from the banker Tom Pollock. They had help getting the business started with a big timber sale that people around town thought was a little suspicious. They were getting paid much more than what they should. Many started referring to the mill as the "Flim Flam." Because of this derogatory nickname, Dolan and Pollock changed the name in 1916 to Flagstaff Lumber Company. The nickname stuck anyway. The company went bankrupt at the end of World War I and was purchased in 1925 by the Cady Lumber Company. In 1931, with the arrival of the Great Depression, the mill went bankrupt. In 1937, the Cady Lumber Company emerged out of bankruptcy with a different name, Southwest Lumber Mills. The name later changed again to Southwest Forest Industries, which outlasted every mill in town. Today, this location is a shopping mall known as Aspen Place.

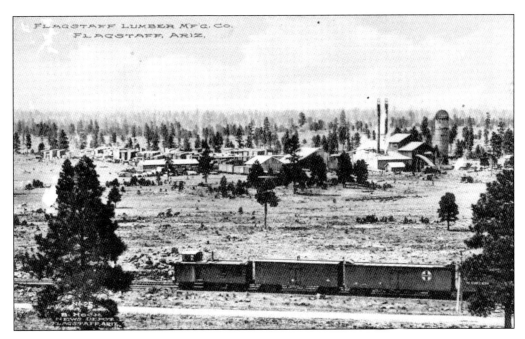

ABOVE AND BELOW: ALBERTYPE POSTCARD, C. 1910S–1920S, PUBLISHED BY B. HOCK NEWS DEPOT. There were three lumber companies that operated logging railroads in the Flagstaff area in the 1910s. There was the Arizona Lumber and Timber Company, the Greenlaw Lumber Mill, and the Flagstaff Lumber Manufacturing Company. Both postcards on this page show views taken from Cherry Hill, located east of downtown Flagstaff. The above postcard is overlooking the railroad and Flagstaff Lumber Manufacturing Company. The postcard below is a view to the southwest. Centered in the background is the Arizona Lumber and Timber Company. Greenlaw Lumber Mill was slightly east of where the Flagstaff Mall is located today.

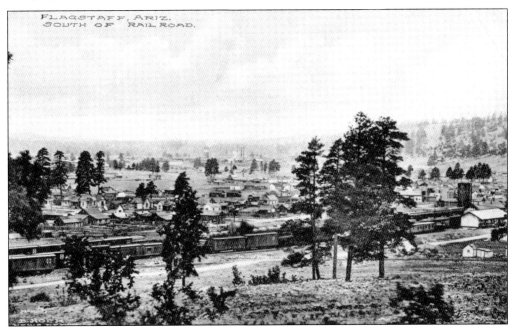

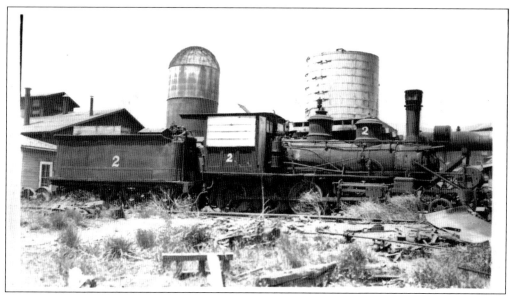

REAL-PHOTO POSTCARD, 1941 WRITTEN DATE. This postcard shows a typical steam locomotive used in the area by the lumber industry. The back of the card mentions that the Arizona Lumber and Timber Company used this locomotive. Today, there are a few examples still visible around Flagstaff. One is in front of the Pioneer Museum and the other is next to the tracks downtown. Using the railroad to transport logs ended in 1966 when trucks were found to be more cost-effective.

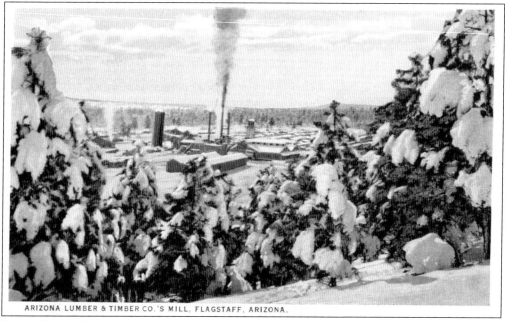

ARIZONA LUMBER & TIMBER CO.'S MILL, FLAGSTAFF, ARIZONA.

CURT TEICH POSTCARD, C. 1920s–1930s, PUBLISHED BY BABBITT BROTHERS TRADING COMPANY. The description on the back of this postcard reads, "Flagstaff is one of the largest lumber producing centers of the United States." This bird's-eye view from Observatory Hill (now Mars Hill) looks southwest at Arizona Lumber and Timber Company's Mill. This mill has seen many names over its history: Ayers Mill (1882–1887), Arizona Lumber Co. (1887–1893), and Arizona Lumber & Timber Co. (1893–1933)

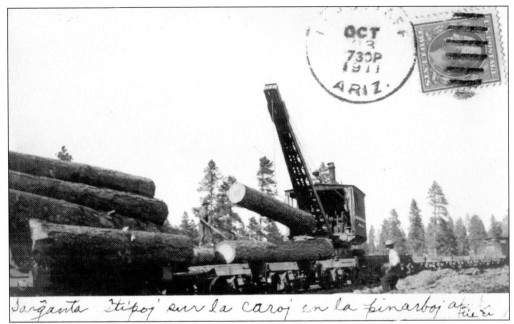

Sarĝanta ŝtipoj' sur la caroj en la pinarboj a...

ABOVE: UNDIVIDED BACK POSTCARD, 1911 POSTMARK. BELOW: UNDIVIDED BACK POSTCARD, 1906 POSTMARK. Steam loaders were steam-powered cranes that lifted logs on and off railcars. The loaders were attached to rails on the railroad cars and would slide between cars when the cars were filled to capacity. The loader would pull itself back one car so that the abandoned car could be utilized. The steam loader was also used as a "yarder" in many circumstances. It could drag a log from as far away as 2,000 feet back to itself. Without the presence of steam loaders, the method of loading logs onto railcars, wagons, or trucks was the process of cross-hauling. Logs would be pulled up ramps and dragged from the other side with the use of ropes or chains. Animals or machinery were usually used for the pulling.

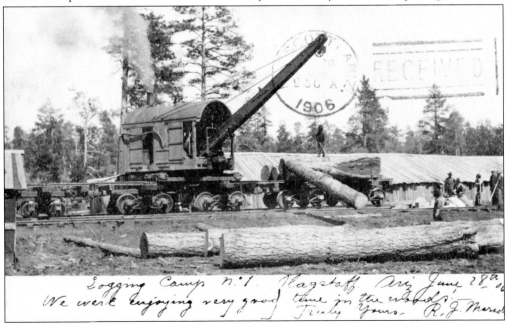

Logging Camp n.°1. Flagstaff Ariz June 28th '06
We were enjoying very good time in the woods. Truly Yours. R. J. Muro...

27

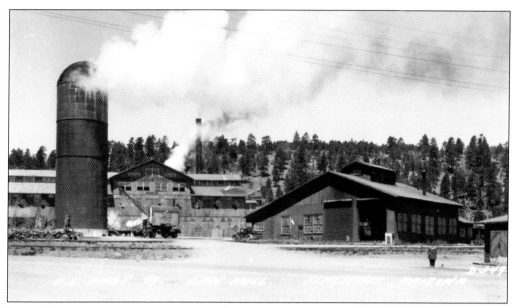

REAL-PHOTO POSTCARD, C. 1940S. The Arizona Lumber and Timber Company became a victim of the Great Depression and had to cease its operations. The year 1933 marked the end of the Riordan era after Tim Riordan sold the Arizona Lumber and Timber Company to Joe Dolan. By 1935, Joe Dolan had the business up on its feet and running strong. In 1940, Joe Dolan sold the operation to the Saginaw-Manistee Company. In 1953, Southwest Lumber Mill acquired Saginaw-Manistee Lumber Company. In 1954, the mill was shut down for good.

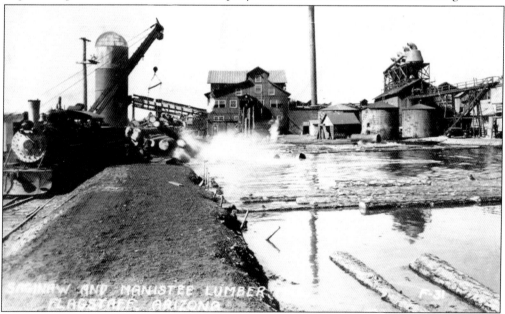

REAL-PHOTO POSTCARD, 1947 POSTMARK. This postcard illustrates how logs were unloaded from the railcars into the millponds. The millponds served a few purposes. First, they made handling and transportation of the logs to the mill easier. Second, they would help clean the logs and rid them of any rocks that may have lodged in them from being dragged on the ground. These rocks could pose a serious threat when they came in contact with the saw in the mill.

Three

CAMPUS

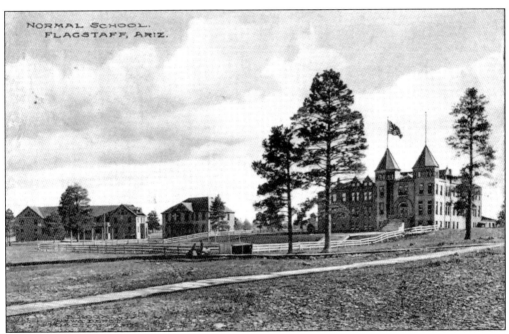

ALBERTYPE POSTCARD, 1911 POSTMARK, PUBLISHED BY B. HOCK NEWS DEPOT. The letter on the back of the postcard reads, "Nov. 27, 1911. To Miss Elizabeth, We are at last settled in the new home and how I wish you might come in and see how cozy we are. Flagstaff people are fine to me and I no longer feel a stranger. Had dinner party in our house, party of 9 ladies. . . . Do write me. Address just Flagstaff, Ariz. Love to you, Marissa."

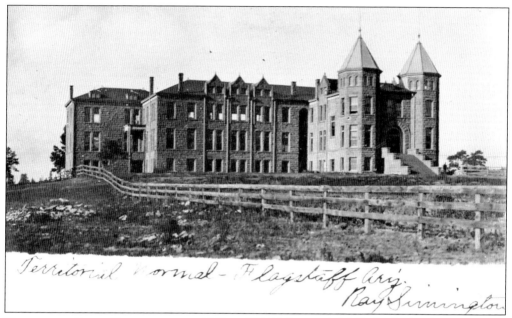

Territorial Normal - Flagstaff Ariz.
Ray Limington

UNDIVIDED BACK POSTCARD, C. 1900s. Old Main was initially built for the purpose of a reform school. After a lack of funds to finish the building and much displeasure from the residents of Flagstaff, many locals traveled to the state legislature and lobbied for the structure to be turned into a normal school or other educational institution. With much passion and commitment from many Flagstaff citizens, the proposal was passed on March 11, 1899.

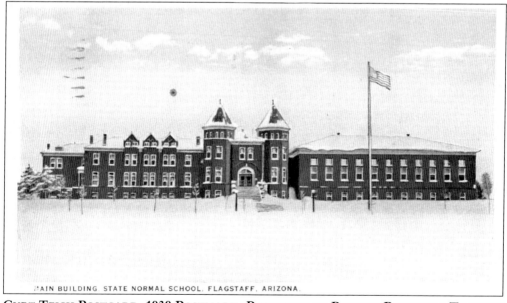

MAIN BUILDING STATE NORMAL SCHOOL, FLAGSTAFF, ARIZONA.

CURT TEICH POSTCARD, 1939 POSTMARK, PUBLISHED BY BABBITT BROTHERS TRADING COMPANY. The west wing of Old Main was built in 1920. Ashurst Auditorium was included with the addition. Another change that happened shortly after was the school's name. In order to be competitive with educating teachers, the school had to start using a four-year program that would lead to a bachelor's degree in education. On July 1, 1925, the school's name was changed to Northern Arizona State Teachers College.

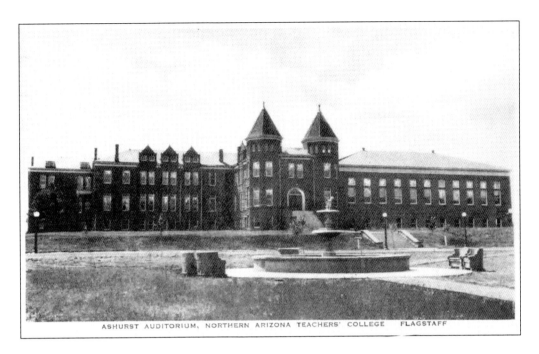

ASHURST AUDITORIUM, NORTHERN ARIZONA TEACHERS' COLLEGE FLAGSTAFF

ABOVE: ALBERTYPE POSTCARD, C. 1920S, PUBLISHED BY CITY DRUG STORE; BELOW: ALBERTYPE HAND-COLORED POSTCARD, C. 1930S, PUBLISHED FOR STILLWELL'S NEWS SERVICE. This institution has seen many different names over the years: Northern Arizona Normal School (1899–1925), Northern Arizona State Teachers College (1925–1929), Arizona State Teachers College at Flagstaff (1929–1945), Arizona State College at Flagstaff (1945–1966), and Northern Arizona University (1966–present). The title for the postcard below is "Administration Building, Arizona State Teachers College."

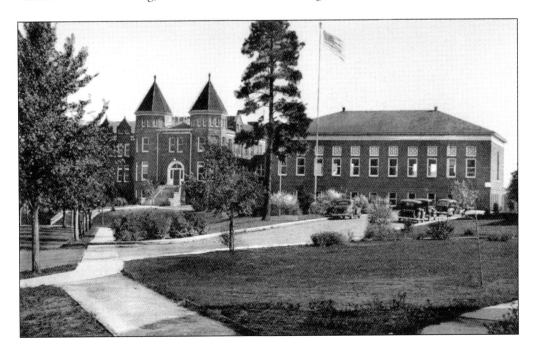

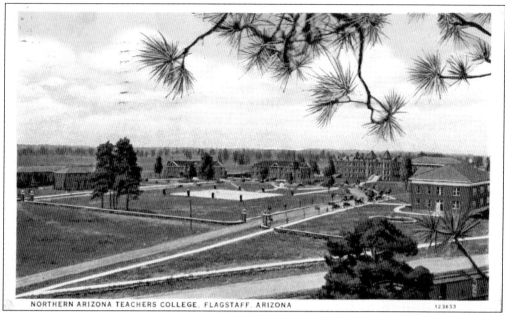

NORTHERN ARIZONA TEACHERS COLLEGE, FLAGSTAFF, ARIZONA 123653

CURT TEICH POSTCARD, 1929 POSTMARK, PUBLISHED BY BABBITT BROTHERS TRADING COMPANY. The description on the back of this postcard reads, "Flagstaff is the home of the Northern Arizona State Teacher's College, an all year institution with four year courses for training teachers in all grades, from kindergarten to twelfth inclusive. . . . At an altitude of 6900 feet the Summers are cool, creating an ideal condition for study during the ten weeks Summer Session."

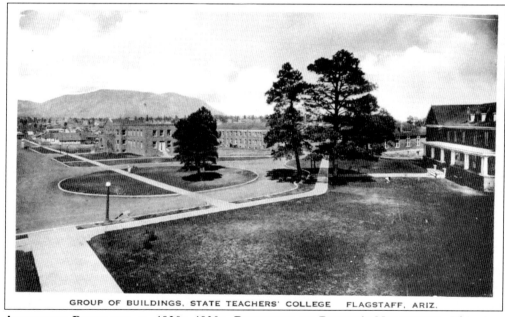

GROUP OF BUILDINGS, STATE TEACHERS' COLLEGE FLAGSTAFF, ARIZ.

ALBERTYPE POSTCARD, C. 1920S–1930S, PUBLISHED BY BROWN'S NEWSSTAND. This view was taken from Taylor Hall looking north towards the "Women's Quadrangle," which encompasses Morton Hall and Campbell Hall. Taylor Hall was named in 1920 after Almon Taylor, Northern Arizona Normal School's first president. It was built in 1905 and was the first dormitory on campus. On the right is Bury Hall, named after Frances Bury, one of the school's first instructors.

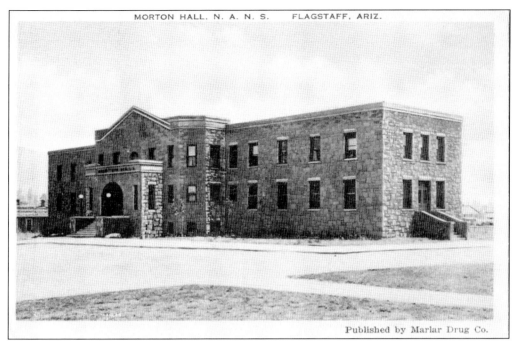

MORTON HALL. N. A. N. S. FLAGSTAFF, ARIZ.

Published by Marlar Drug Co.

ALBERTYPE POSTCARD, C. 1920S–1930S, PUBLISHED BY MARLAR DRUG COMPANY. Morton Hall was named after Mary Morton Pollock and opened in 1918. She was married to Thomas E. Pollack, a well-known banker and politician in town. She started teaching English at the Northern Arizona Normal School in 1907 and would become the head of the department. She and her husband were very active in the community.

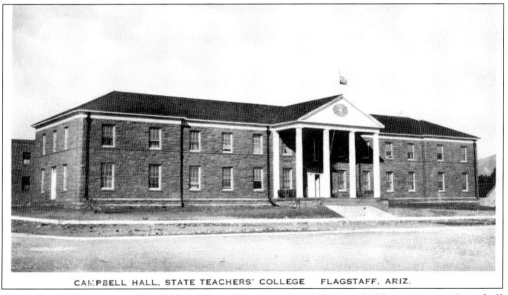

CAMPBELL HALL, STATE TEACHERS' COLLEGE FLAGSTAFF, ARIZ.

ALBERTYPE POSTCARD, C. 1920S–1930S, PUBLISHED BY BROWN'S NEWSSTAND. Campbell Hall (originally known as Babbitt Hall) started being used in 1916 and was named after state senator Hugh Campbell. He was a sheep rancher and was president of the Arizona Wool Growers Association. He represented Coconino County as a state senator for almost 10 years. This dormitory bears his name to honor his strong support of this institution.

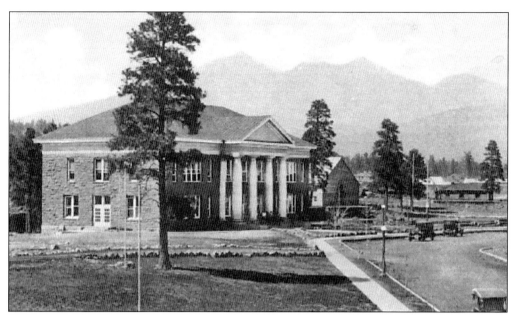

ALBERTYPE POSTCARD, C. 1920S–1930S, PUBLISHED BY BROWN'S NEWSSTAND. The Blome building was named in honor of the school's second president, Rudolph Harin Heinrich Blome, in 1982. He was hired in 1909 and served until 1918, during World War I, when the school dismissed him because of his German background. This building was opened in 1921 and was used as the training school for Northern Arizona Normal School.

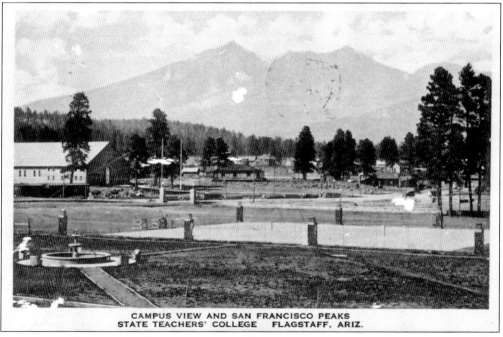

CAMPUS VIEW AND SAN FRANCISCO PEAKS
STATE TEACHERS' COLLEGE FLAGSTAFF, ARIZ.

ALBERTYPE POSTCARD, 1930 POSTMARK, PUBLISHED BY BROWN'S NEWSSTAND. This image was taken from Old Main looking north. The building on the left is the armory. Centered in the postcard are some tennis courts. The campus fountain is in the lower left corner. Also pictured are a couple of railcars parked on the track in front of the armory.

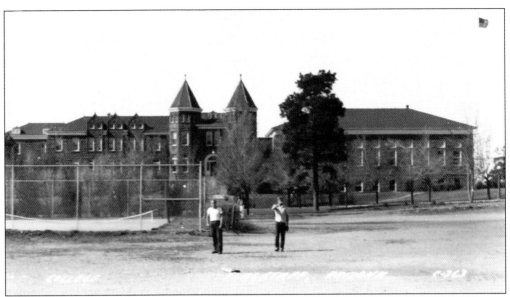

REAL-PHOTO POSTCARD, C. 1930S–1940S. This postcard shows two men playing baseball. Sports were a big part of college life. Many athletic fields were spread over the campus. McMullen Field was south of the college. Skidmore Field was used instead of McMullen Field in the 1930s and was on the east side of campus. In 1937, Waggoner Fields were donated to the college by W.H. Waggoner of the Arizona Livestock Company and became the future site of Lumberjack Stadium, which has been recently renovated to become part of the new state of the art Health and Learning Center.

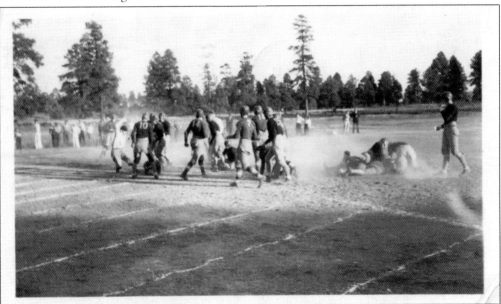

REAL-PHOTO POSTCARD, 1933 POSTMARK. This postcard's letter reads, "We had nice weather until today. Snow is coming. This is the Prescott–Flagstaff game played here. Willard is No. 7. Hope you are fine. We are. Love, Hallie." This game was probably held on McMullen Field. Located just south of Old Main, it was the first named athletic facility at the school and was used until the 1950s. The field mostly consisted of dirt, which made activities very dusty.

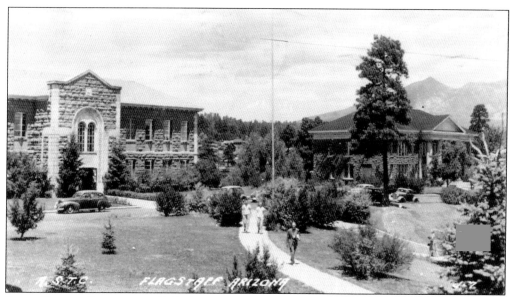

REAL-PHOTO POSTCARD, 1949 POSTMARK. Pictured are the Gammage Building (left) and the Blome Building (right). The Gammage Building was constructed in 1930 and was named after the school's seventh president, Grady Gammage, in 1933. The library was moved from Old Main to this facility, as well as the college's administrative offices. The message on the back reads, "Just a few lines to find out if your still alive down that way. Schools out tomorrow. Thank the lord. Love, Marty."

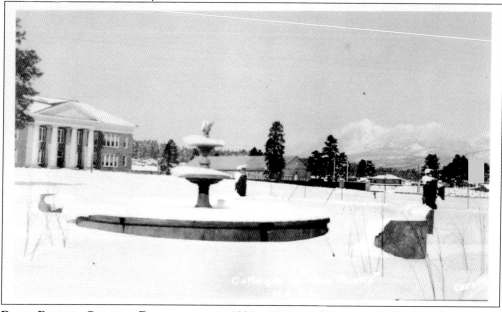

REAL-PHOTO CARSON POSTCARD, C. 1930s–1940s. This postcard displays the campus fountain that was located in front of Old Main. In 1951, someone destroyed the fountain by using sticks of dynamite, probably as a prank. The fountain's base was rebuilt and was used as a flowerbed. It became a favorite spot for many students because of the shrubbery hiding the area. Many used the area as a "romantic getaway." In 1999, Northern Arizona University built an ornate, pedestal clock in its place.

Four

HISTORIC DOWNTOWN

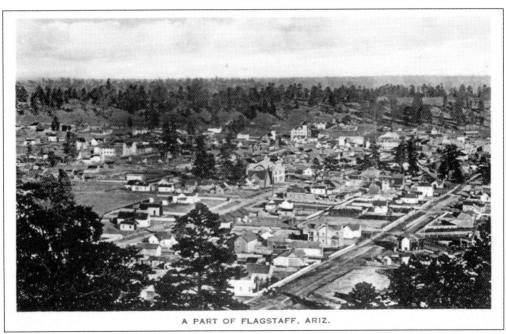

A PART OF FLAGSTAFF, ARIZ.

ALBERTYPE POSTCARD, 1922 POSTMARK, PUBLISHED BY THE NEWS STAND. This bird's-eye view of Flagstaff was taken from Observation Mesa (known today as Mars Hill). The message on the reverse reads, "March 27, 1922. Dear Friend, Some change up here, but not as cold as expected it would be. Snow all melted away. Hope you are well. Don't expect to stay long. Sincerely, Grace." The letter was addressed to Phoenix.

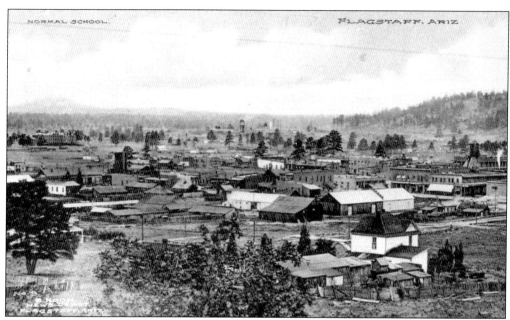

ALBERTYPE POSTCARD, 1918 POSTMARK, PUBLISHED BY B. HOCK NEWS DEPOT. This image looks southwest across town, with the Northern Arizona Normal School in the background on the left. Familiar structures include the Weatherford Hotel and Babbitt Building. The letter on the reverse reads, "Dear Rose: Please consider all engagements for Thursday void, since Father and Mother are both sick with the grippe. Alan."

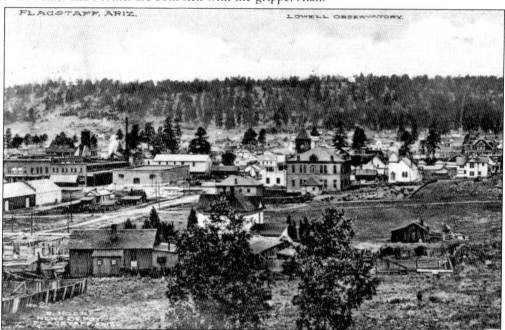

ALBERTYPE POSTCARD, 1912 POSTMARK, PUBLISHED BY B. HOCK NEWS DEPOT. This image was taken from atop Cherry Hill looking west. Lowell Observatory can be seen faintly in the background. Slightly below that, a little right of center, the clock tower on the Coconino Courthouse is visible. The letter on the reverse is addressed to Sweden and is written in Swedish.

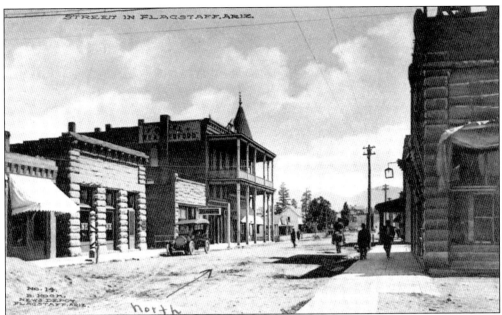

ALBERTYPE POSTCARDS, C. 1910S–1920S, PUBLISHED BY B. HOCK NEWS DEPOT. This photograph looks north on Leroux Street—named after Antoine Leroux, a scout and guide during many major expeditions through the area before Flagstaff existed. In 1851, he helped guide Capt. Lorenzo Sitgreaves on a survey to build a road through the San Francisco Mountain region. It is considered to be the first official expedition to the area.

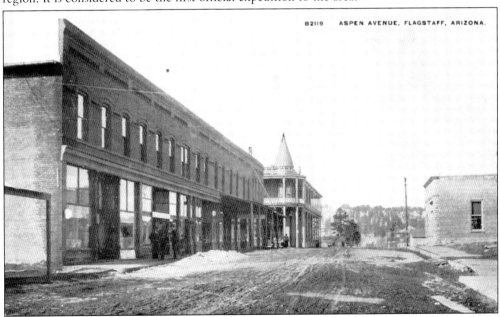

DIVIDED BACK POSTCARD, 1920 POSTMARK, C.M. FUNSTON, PUBLISHER. On the south side of Aspen Avenue (at left) stands the Sanderson Building, constructed in 1899. Bettie A. Sanderson borrowed money from the Arizona Central Bank (directly across the street) to construct the building and defaulted on her loan a few years later. Banker Thomas E. Pollock added the second story in 1903. It housed the public library from 1914 to 1938.

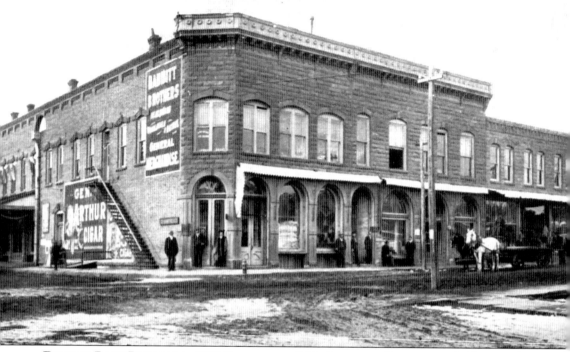

DIVIDED BACK POSTCARD, 1908 POSTMARK, C.M. FUNSTON, PUBLISHER. Babbitt Brothers Trading Company was established in 1889. This building was built in 1888 and was primarily used as a general store. There were five "original" Babbitt brothers: David, George, William, Charles, and Edward. During this time, the Babbitts dealt with many different operations: They owned and operated many retail shops in Northern Arizona, they were automobile dealers, operated numerous trading posts on the Indian reservations, ran Flagstaff's only ice plant, operated an opera hall, owned a livery stable, ran the mortuary, and dealt with slaughtering and meat packing. They were also known for their ranching operations. The first brand the Babbitts used was "CO Bar," named after Cincinnati, Ohio, where the family came from. Land and cattle acquisition by the Babbitts around the turn of the 20th century was impressive. Nearly 100 brands came under Babbitt control after the founding of CO Bar in 1886. Babbitt cattle and sheep ranches covered three million acres in three states.

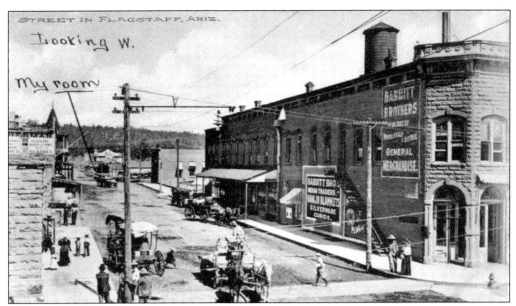

ALBERTYPE POSTCARD, 1912 POSTMARK, PUBLISHED BY B. HOCK NEWS DEPOT. This image looks west down Aspen Avenue. The Babbitt Building was expanded in 1891, and the Babbitts turned the extra area into the "Babbitt Opera Hall." The facility was often used for entertainment, concerts, and civic functions. The letter on back reads, "Dearest Laura: How you was? Got the knot tied last Sat. night. You're next. Yes, it's just as you say. Nothing like it. . . . Lots of love, Mrs. Haynes."

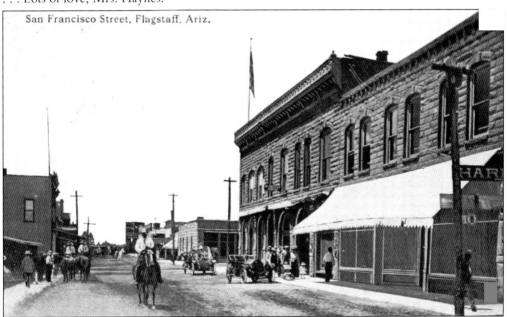

CURT TEICH POSTCARD, 1912 POSTMARK, PUBLISHED BY THE HUNTER DRUG COMPANY. This postcard is looking south on San Francisco Street. The Babbitt Building also housed Coconino County administrative offices before the Courthouse was built. The Babbitt family had a significant influence in making Flagstaff into what it is today. They were very active in civic decisions about the town.

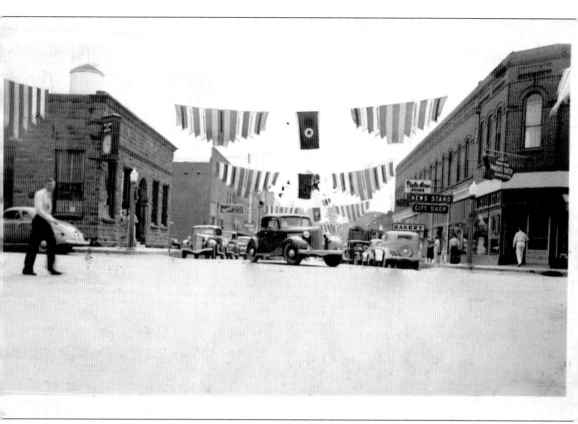

REAL-PHOTO POSTCARD, 1938 POSTMARK. This postcard shows the view east toward the intersection of Leroux and Aspen Streets. Most likely, the picture was taken during the Fourth of July. Flagstaff has always been known for celebrating the Fourth of July with large parades and festivities. The Southwest All-Indian Pow-Wow was also a popular event during this holiday. Tribes from all over the country would parade through town, conduct rodeos, perform traditional dances, and hold spiritual ceremonies. This attraction would bring crowds of up to 100,000 people. These large crowds were the beginning of the end of the Pow–Wow in Flagstaff. Festival volunteers were unable to control the revelers and the Flagstaff tradition came to an end in 1980. The letter on the reverse says, "8th of January, 1938. Dear Mother, Having a swell time but wonder how you ever landed in Flagstaff. Cold . . . Oh Boy!!! Has Nothing on New Jersey. Love to all. William."

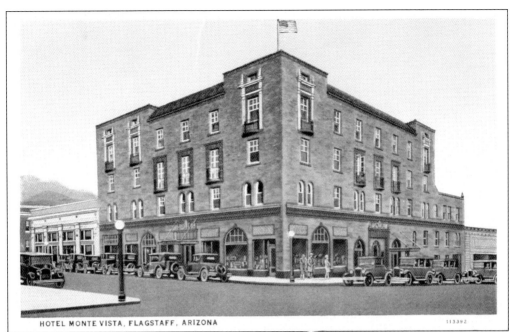

HOTEL MONTE VISTA, FLAGSTAFF, ARIZONA 113392

ABOVE: CURT TEICH POSTCARD, 1931 POSTMARK, PUBLISHED BY BABBITT BROTHERS TRADING COMPANY. LEFT: DIVIDED BACK POSTCARD, C. 1940S. The Monte Vista Hotel held its groundbreaking ceremony on June 8, 1926. Originally named the Community Hotel, it opened its doors on New Year's Day, 1927. At the time, it was the tallest building in Flagstaff and contained 73 guest rooms. The city felt there was a need for a more modern hotel. Fundraising brought in about $200,000 through investments from the public, hence the name Community Hotel. The name Monte Vista, meaning "mountain view," came about through a renaming contest. Today, many of the rooms are named after celebrities who have previously stayed there.

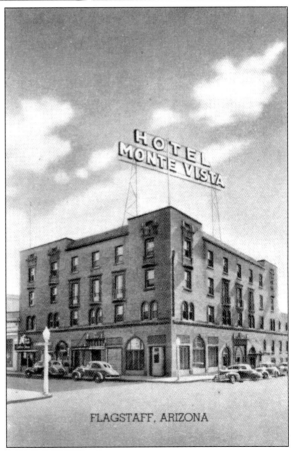

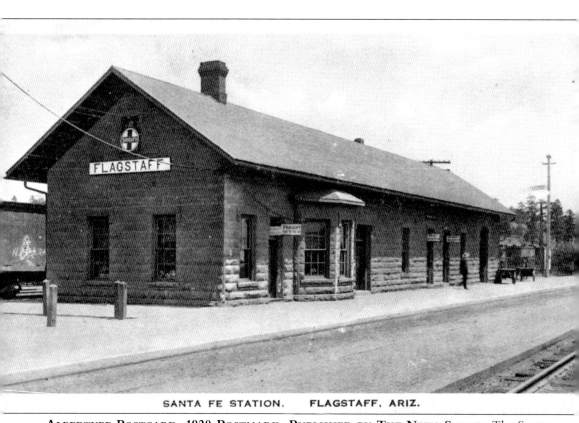

SANTA FE STATION. FLAGSTAFF, ARIZ.

ALBERTYPE POSTCARD, 1920 POSTMARK, PUBLISHED BY THE NEWS STAND. The Santa Fe Station, in the postcard above, was utilized during the years 1889–1926. It replaced another depot that was built in 1886 and burned down in 1888. Initially, the depot consisted of a few boxcars from the railroad. The railroad decided on this location, "New Town," due to it being on level ground. Originally, the train would stop at "Old Town," where Flagstaff's first settlements were established. The trains stopped there to utilize a spring situated there (Antelope Springs) but had a difficult time starting out with the uphill grade heading west. Originally known as the Atlantic & Pacific Railroad, it went bankrupt in 1894 and then became the Atchison, Topeka & Santa Fe in 1902. It later changed to just Santa Fe, then briefly to Santa Fe Southern Pacific. Today it's known as Burlington Northern Santa Fe and the structure is used as offices for the railway.

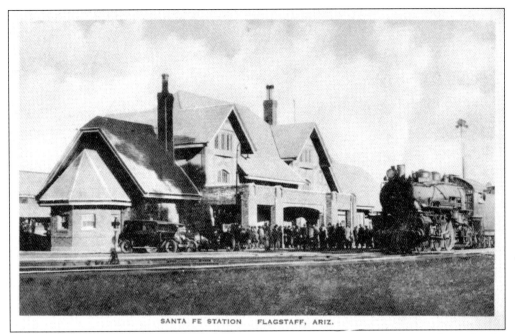

SANTA FE STATION FLAGSTAFF, ARIZ.

ALBERTYPE POSTCARD, C. 1920S, PUBLISHED BY THE NEWS STAND. The grand opening for this Santa Fe Station occurred on January 5, 1926. The station was constructed to accommodate more business and passengers. The other depot was considered a little small compared to the importance of Flagstaff to the railroad. Water issues facing the town and the railroad were becoming a serious dilemma at the time. With negotiations between city leaders and the railroad, the issues of water rights and having a predominant depot were settled.

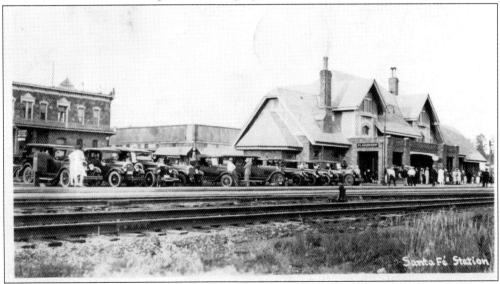

REAL-PHOTO POSTCARD. 1929 POSTMARK. The grandeur of the station has not changed too much over the years. Today, the building is used for the Flagstaff Visitor's Center as well as an Amtrak Station. The letter reads, "Tues. Just a line to tell you I will write soon. Glen and Edith were here all last week so I have been so busy and have changed the music meeting Sat. All are well. Willard weighs 99 lbs. Love, Hallie."

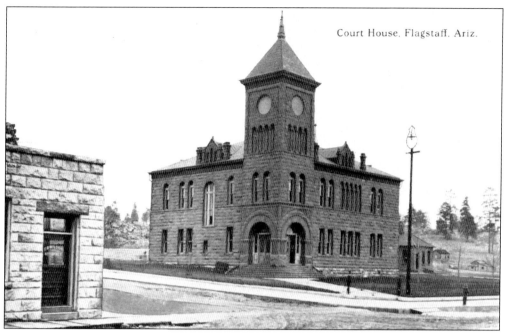

Court House, Flagstaff, Ariz.

ABOVE: CURT TEICH POSTCARD, 1922 POSTMARK, PUBLISHED BY THE HUNTER DRUG COMPANY; BELOW: ALBERTYPE POSTCARD, C. 1920S, PUBLISHED BY O.B. RAUDEBAUGH. Construction of the Coconino County Courthouse began in 1894 and was not completed until the summer of the following year. The building is made from local red Moenkopi sandstone. Allen A. Dutton and T.F. McMillan are responsible for suggesting Flagstaff's need for this structure. The money saved from not having to pay rent for various locations around town (including the upper floor of the Babbitt Building) was the primary reason for its creation. These four postcards of the courthouse demonstrate how the building evolved between 1910 and 1940.

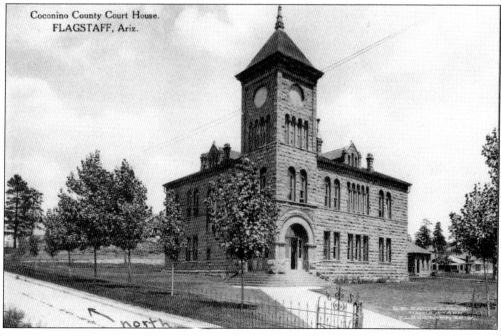

Coconino County Court House.
FLAGSTAFF, Ariz.

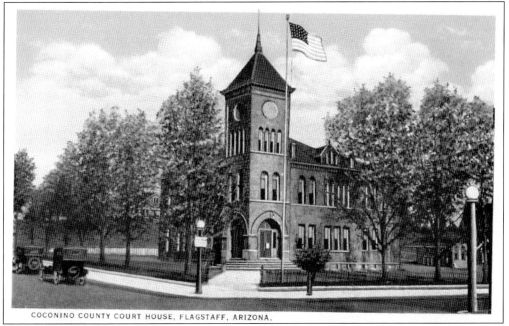

COCONINO COUNTY COURT HOUSE, FLAGSTAFF, ARIZONA.

CURT TEICH POSTCARD, C. 1920S, PUBLISHED BY BABBITT BROTHERS TRADING COMPANY. Coconino County was established in 1891. Today it is the second-largest county, based on area, in the continental United States—larger than nine states. San Bernardino County in California is the largest.

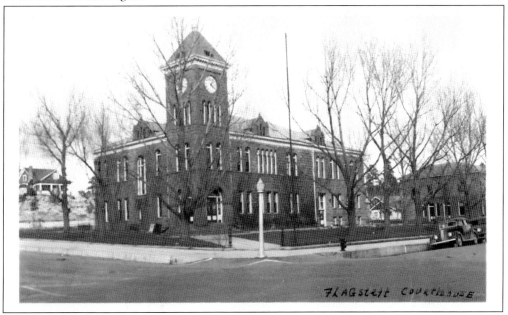

REAL-PHOTO POSTCARD, 1941 POSTMARK. Due to the increase in Flagstaff's population, the county found the need to expand the building in 1926. This project included the installation of the clocks on only two sides of the tower. Over the years, the look of the building has changed many times. Additions were added during the 1950s, 1960s, and 1970s. In 2002, most of the cosmetic changes were reversed and the building was restored to its original grandeur.

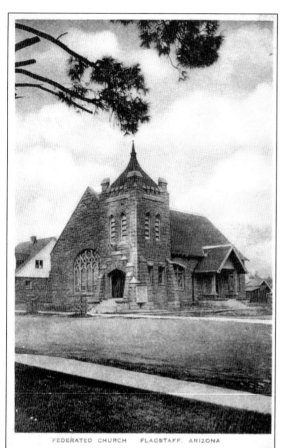

FEDERATED CHURCH FLAGSTAFF, ARIZONA

ALBERTYPE POSTCARD, 1937 POSTMARK, PUBLISHED BY CITY DRUG STORE. The Federated Community Church was built in 1907. It is located on Aspen Avenue, once known as Church Avenue. The church was constructed to accommodate the growing number of members. They had outgrown their previous building located on Aspen Avenue and Leroux Street. The Methodists and Presbyterians joined to become the Flagstaff Federated Community Church in 1906.

REAL-PHOTO POSTCARD, C. 1930s. The Episcopal Church of the Epiphany started construction in 1912 and opened its doors in March 1913. Built out of malpais rock, it is located on north Beaver Street. Dr. Edwin S. Miller, Mrs. T.J. Coalter, and Eli Giclas started the church in 1902.

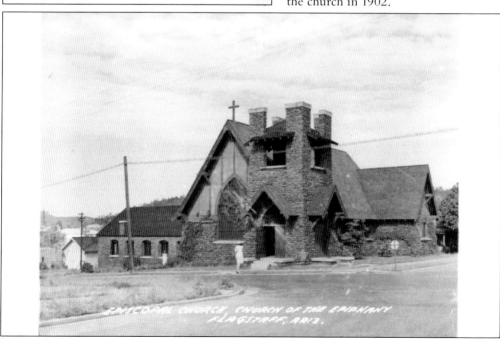

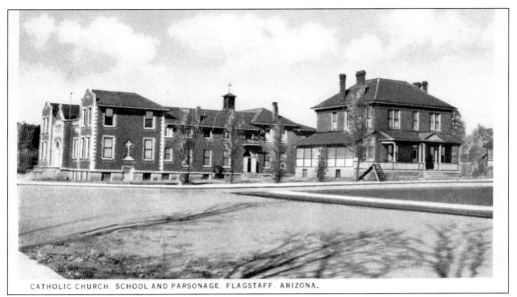

CATHOLIC CHURCH, SCHOOL AND PARSONAGE, FLAGSTAFF, ARIZONA.

CURT TEICH POSTCARD, C. 1930S, PUBLISHED BY BABBITT BROTHERS TRADING COMPANY. St. Anthony's Academy was built around 1900. In 1911, many Catholics decided to change churches. In 1912, major renovations were being done to the chapel of St. Anthony's School. In 1930, the parishioners moved again, but across the street to the Church of the Nativity of the Blessed Virgin Mary. In 1955, St. Anthony's School was demolished due to deteriorating conditions and was replaced with a larger school (St. Mary's). Today, it is known as the San Francisco De Asis Catholic School.

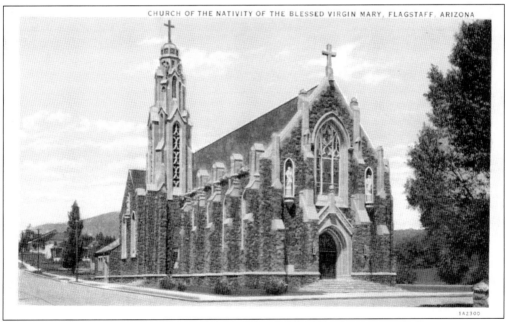

CHURCH OF THE NATIVITY OF THE BLESSED VIRGIN MARY, FLAGSTAFF, ARIZONA

CURT TEICH POSTCARD, C. 1930S, PUBLISHED BY BABBITT BROTHERS TRADING COMPANY. The message reads, "This church is unique in design and material being the only one on this continent built of native malpais or volcanic rock covered with natural green lichen, it was dedicated Dec. 7, 1930, by the Most Reverend Daniel J. Gercke, Bishop of the Diocese of Tucson."

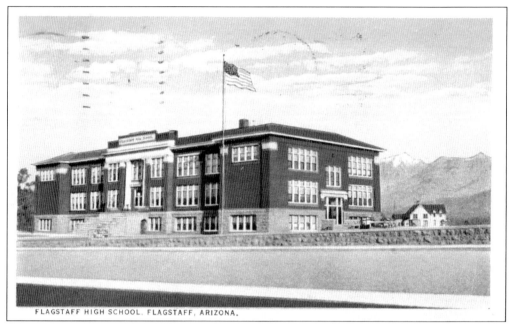

FLAGSTAFF HIGH SCHOOL, FLAGSTAFF, ARIZONA.

Curt Teich Postcard, 1936 Postmark, Published by Babbitt Brothers Trading Company. Classes started at Flagstaff High School in the fall of 1923. Flagstaff at this point hosted one high school and four grade schools. John Q. Thomas was the superintendent from 1921 to 1947. The school was demolished in 1970 to create space for more educational facilities.

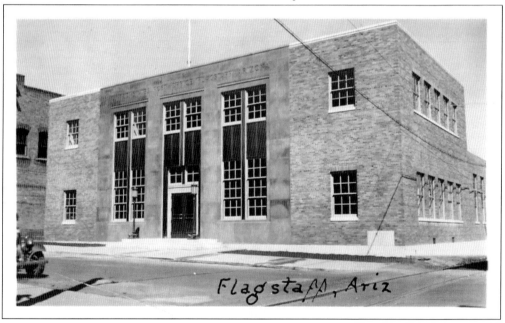

Real-Photo Postcard, 1939 Postmark. Today, this building on north San Francisco Street is the Federal Building. Construction started in 1935 and it opened as a post office on June 4, 1937. The money for the building came from Franklin D. Roosevelt's New Deal. It was Flagstaff's fifth post office. The building material used for this structure came from recycled stone taken from the Los Angeles Courthouse, which was being demolished at the time.

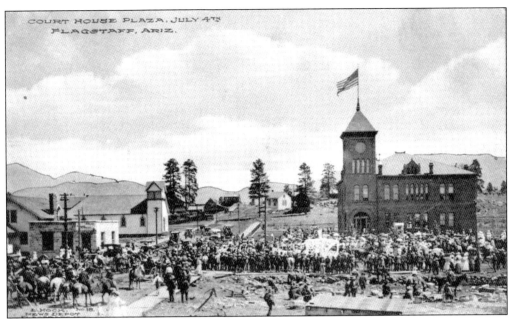

ABOVE AND BELOW: ALBERTYPE POSTCARD, C. 1910S, PUBLISHED BY B. HOCK NEWS DEPOT. Apparently, both of these postcards were taken on the same day: July 4, 1911. The image above is looking north on San Francisco Street, while the one below is looking south. The celebration of the Fourth of July has always had special meaning to the people of Flagstaff. The year 1911 on these postcards is significant, as that was the last Fourth of July celebration in Flagstaff while Arizona was still a territory. Arizona became the 48th state on February 14, 1912. At first, Pres. William Howard Taft wanted to have a ceremony on February 12, Abraham Lincoln's birthday. He felt that date was fitting because Lincoln helped create the Arizona Territory in 1863. The ceremony at the White House was delayed because President Taft wanted a clause in the state constitution removed.

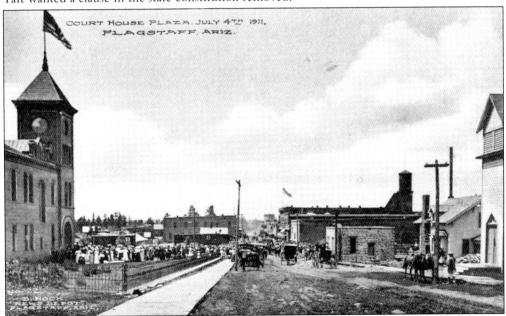

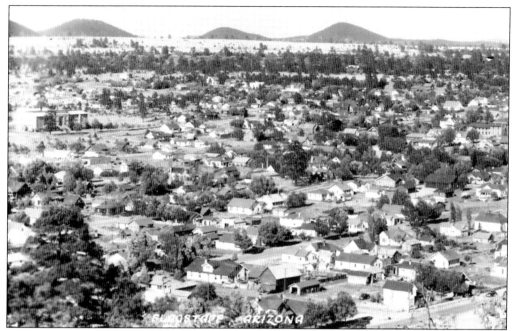

REAL-PHOTO POSTCARD, C. 1940s–1950s. This postcard image was taken from Mars Hill looking northeast and demonstrates the population growth Flagstaff has experienced since its early days. In 1890, Flagstaff's population was 963 people. In 1920, it was 3,186. In 1950, the population was 7,663; it more than doubled in the following decade to 18,214 in 1960. In 2000, the population was 52,894 and in 2010 it was 70,216.

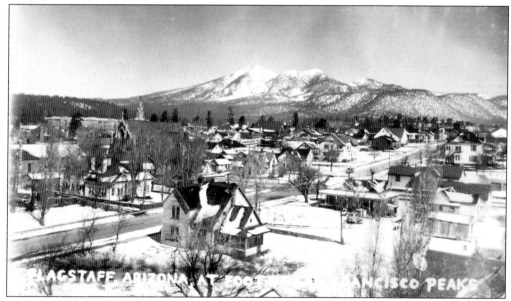

REAL-PHOTO POSTCARD, C. 1930s–1940s. This image was most likely taken from the Coconino County Courthouse and shows a typical winter's day with snow covering the town. The average annual snowfall in Flagstaff is approximately 110 inches. The record for most snow in a season was during the 1972–1973 winter, when 210 inches fell. The one-day snowfall record for Flagstaff occurred on December 30, 1915, with 31 inches.

Five

"In-Town" Attractions

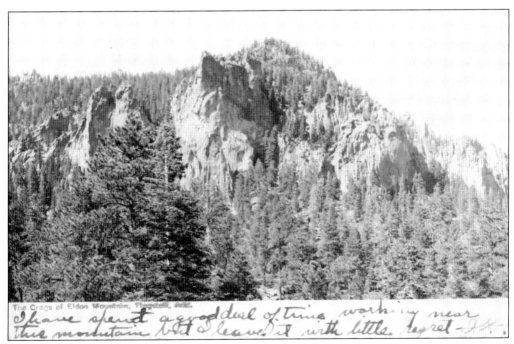

The Crags of Elden Mountain, Flagstaff, Ariz.

I have spent a good deal of time working near this mountain but I leave it with little regret — J.H.

Divided Back Postcard, 1907 Postmark. Mount Elden (altitude 9,280 feet) was named after a sheep rancher and one of the earliest settlers of Flagstaff, John Elden. He had three children: Helena, Eloise Felicia, and John. His son John was accidentally shot and killed at the age of six by a reckless rancher looking to water his mules. In 1977, Mount Elden suffered a disastrous fire named the "Radio Fire."

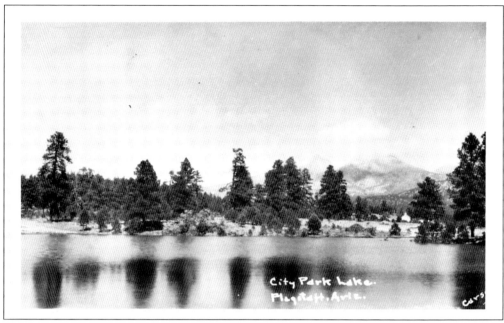

ABOVE: REAL-PHOTO CARSON POSTCARD, C. 1930S; BELOW: CURT TEICH LINEN POSTCARD, 1951 POSTMARK. The City Park Lake had multiple reasons for its existence. In 1923, a dam was built in order to regulate the damaging floods of the past. The pond was also used by the railroad. It was the closest water source in town that was able to provide enough water for the steam locomotives. During the 1970s, a Flagstaff Junior High biology teacher by the name of Jim David helped make this lake into an "outdoor classroom" to study wetland habitats. In 1993, it was named Frances Short Pond in honor of the city council member and middle school teacher.

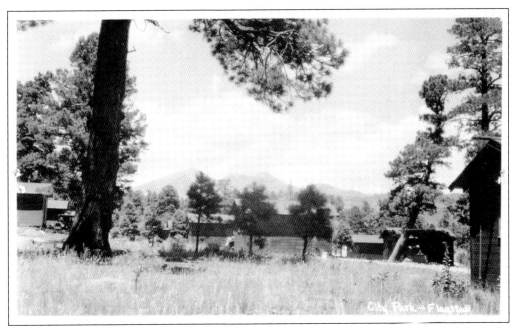

REAL-PHOTO POSTCARD, C. 1930S. During the summers, the student population at the college grew drastically. Students from the surrounding deserts would enroll for summer courses due to the comfortable climate. There was not enough housing on campus so some students would utilize these cabins. Some are still standing today near Francis Short Pond.

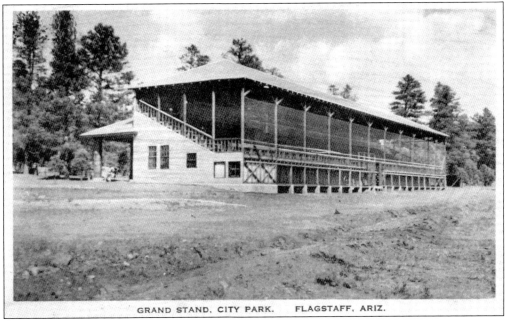

ALBERTYPE POSTCARD, 1924 POSTMARK, PUBLISHED BY BROWN'S NEWS STAND. This grandstand was located in what is known today as Thorpe Park. Horse and car races were popular events held here. Another popular event in this park was the Southwest All-Indian Pow-Wow from 1930 to 1980. Thorpe Park was named after Col. T.J. Thorp, a Civil War veteran living in Flagstaff at the end of the 1880s.

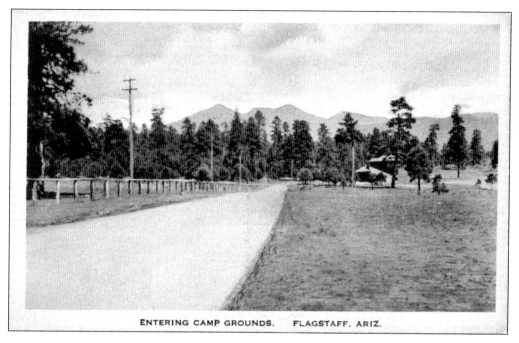

ENTERING CAMP GROUNDS. FLAGSTAFF, ARIZ.

ABOVE: ALBERTYPE POSTCARD, C. 1920S, PUBLISHED BY BROWN'S NEWS STAND; BELOW: ALBERTYPE POSTCARD, 1925 POSTMARK, PUBLISHED BY BROWN'S NEWS STAND. These two postcards illustrate the camping grounds located in Thorpe Park. With the use of the automobile on the rise at the time, many motorists found it easier to carry camping gear in their cars rather than stay in hotels. These public camping grounds were created in 1917 when the City Council acquired a special use permit from the Forest Service. They were located behind the grandstand then. Today, the area is still used for recreation.

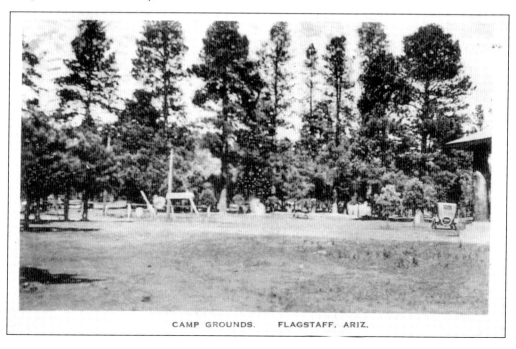

CAMP GROUNDS. FLAGSTAFF, ARIZ.

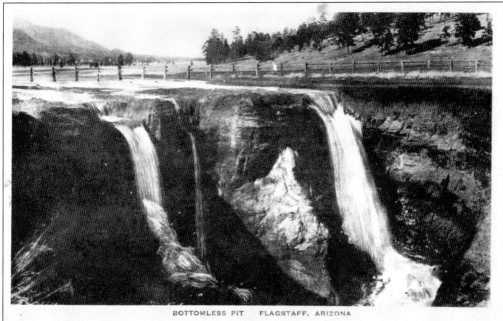

BOTTOMLESS PIT FLAGSTAFF, ARIZONA

UNDIVIDED BACK POSTCARD, PRE-1910. The Bottomless Pit was a very popular tourist attraction on the east end of town. It is carved out from the seasonal water flow from the Rio de Flag. It is thought that the water may find its way to Walnut Canyon. No one knows for sure. The cavern has been a mystery for many.

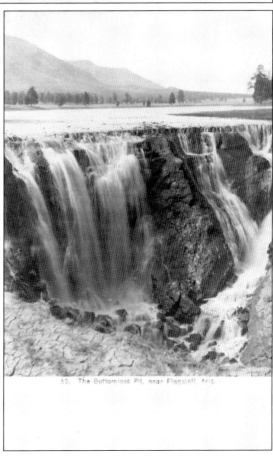

52. The Bottomless Pit, near Flagstaff, Ariz.

DIVIDED BACK POSTCARD, 1913 POSTMARK, PUBLISHED BY B. HOCK. The letter on the back of this card reads as follows: "Dear Friends, Received your card. Glad to hear from you. What do you think of being so close to this place on this card? Well they can't raise as good potatoes here as in Michigan. Believe me, it is a dirty, dusty place. It hasn't rained since I came here, just sprinkled a little. We all expect to start for Michigan the 1st of June. Hope you both are well. I am not sorry I came but will be glad to get home. Mrs. D."

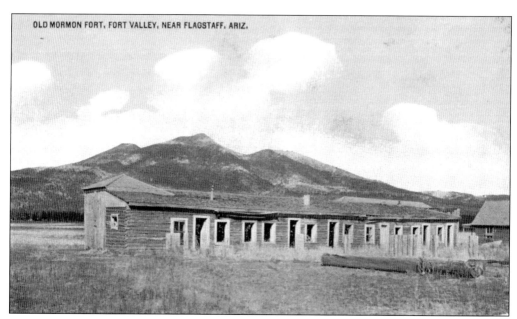

OLD MORMON FORT, FORT VALLEY, NEAR FLAGSTAFF, ARIZ.

DIVIDED BACK POSTCARD, C. 1910S, PUBLISHED BY B. HOCK. Originally known as Fort Moroni, it was built in 1881 by John W. Young, son of Brigham Young. The area was used for cutting railroad ties for the Atlantic and Pacific Railway. Later it became associated with the Moroni Cattle Company, which changed hands to become the Arizona Cattle Company. This is how the Fort Valley area of Flagstaff received its name. Allegedly, it was torn down in 1926 by cowboys who unwittingly used the wood to make a campfire.

IN THE COCONINO FOREST.

a nice place for a Picnic, Eh?

DIVIDED BACK POSTCARD, C. 1910S, PUBLISHED BY B. HOCK. The Coconino National Forest was originally known as the San Francisco National Forest Reserve and established in 1898 by Pres. William McKinley. This action was initiated to help protect many areas of the forest from being clear-cut. The first forest ranger to arrive in Flagstaff was Fred Breen. In July 1908, the reserve was merged with other lands from surrounding forest reserves. It was renamed Coconino and designated a national forest.

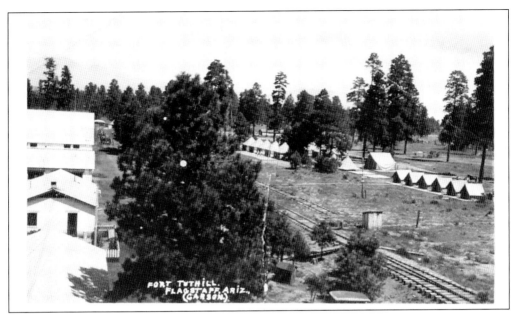

ABOVE: REAL-PHOTO CARSON POSTCARD, C. 1930S; BELOW: REAL-PHOTO CARSON POSTCARD, 1937 WRITTEN DATE. Fort Tuthill was a National Guard training facility located about three miles south of Flagstaff. It was constructed in 1929 and named after Gen. Alexander Mackenzie Tuthill. The facility was used as a field-training site for the 158th Infantry Regiment Arizona National Guard from 1929 to 1937, 1939, and again in 1948. General Tuthill basically had two careers; he was a distinguished surgeon and a general often referred to as "The Father of the Arizona National Guard." He is believed to be the first surgeon to use metal plates in a surgical procedure. For his military career, the general's awards included the first Arizona Medal of Honor ever issued and the United States Medal for Merit, which was awarded by Pres. Harry S. Truman.

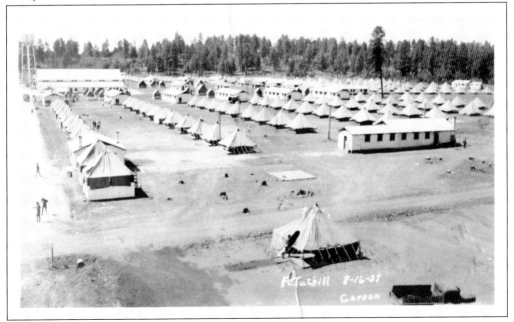

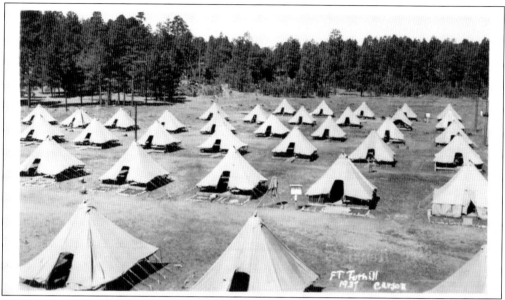

REAL-PHOTO CARSON POSTCARD, 1937 WRITTEN DATE. This postcard displays the squad tents used by the 158th Infantry Regiment. Today, the area is the location for the Coconino County Fairgrounds. Many fairs and fun activities draw large crowds. Horse races are conducted on the old marching grounds. Many of the old facilities are still being used. The Fort Tuthill Military Museum and the Coconino County Park and Recreation offices are housed in some of the structures found on the grounds.

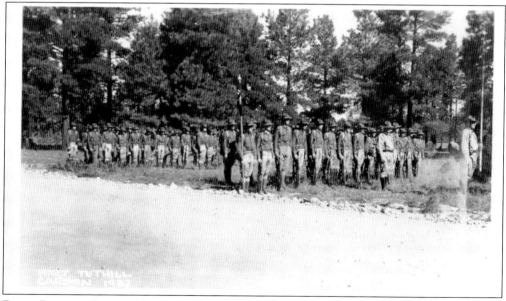

REAL-PHOTO CARSON POSTCARD, 1937 WRITTEN DATE. On May 9, 1916, the 1st Arizona Infantry was called into service. They were stationed on the Mexico border due to raids on American border towns from Mexican revolutionaries associated with Pancho Villa. The mission was called off when the United States entered World War I. The 1st Arizona Infantry Regiment was deployed to France and, on August 3, 1917, became known as the 158th Infantry Regiment.

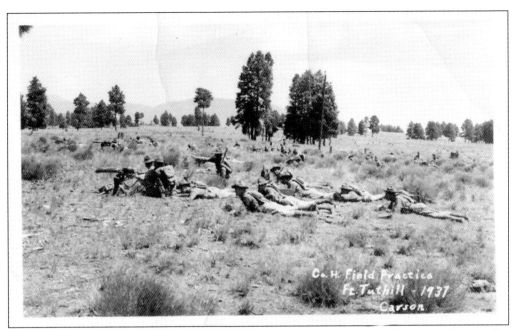

ABOVE AND BELOW: REAL-PHOTO CARSON POSTCARD, 1937 WRITTEN DATE. On September 16, 1940, Pres. Franklin D. Roosevelt ordered the Arizona National Guard into active service. The 158th Infantry Regiment, later named the 158th Regimental Combat Team, was relocated and trained at Fort Sill, Oklahoma, then moved to Camp Barley, Texas. Shortly after the Japanese attack on Pearl Harbor, they were shipped to Panama in 1942. They spent the early part of World War II training in jungle warfare. It was here that the regiment's new name was established. They now were known as "The Bushmasters," named after the deadly snake in Panama. They dealt with heavy fighting during the war and were part of Operation Downfall. This entailed a plan to invade Japan if the Atomic Bomb did not convince Japan to surrender. Bushmaster Park, one of Flagstaff's recreational parks, is named in honor of this regiment.

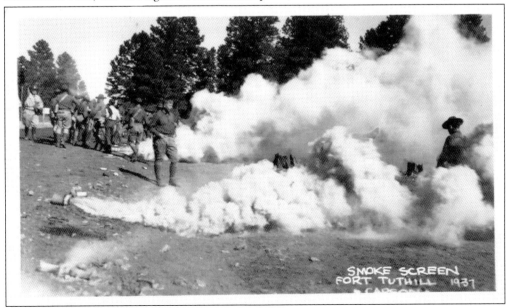

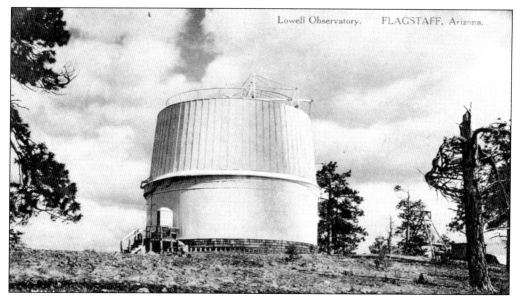

DIVIDED BACK POSTCARD, 1918 POSTMARK, PUBLISHED BY WILL MARLAR PHARMACY.
The astronomer Percival Lowell founded Lowell Observatory on Mars Hill in 1894, making it
one of the oldest observatories in the United States. Mars Hill was named after Percival Lowell's
profound interest in the planet and his belief in life on Mars. Pictured is the Alvan Clark Dome,
which housed the 24-inch Clark telescope. Also located on Mars Hill is the 13-inch refractor
telescope used by Clyde Tombaugh in 1930 to discover the dwarf planet Pluto.

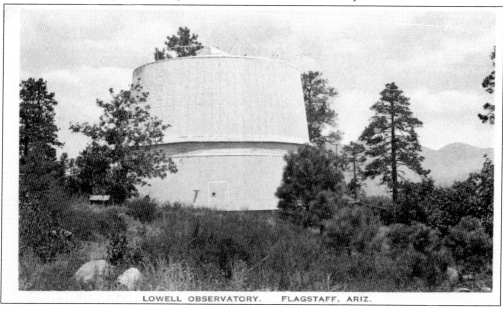

ALBERTYPE POSTCARD, 1919 POSTMARK, PUBLISHED BY THE NEWS STAND. The letter
on the back reads, "July 15, 1919. We are camping among the pines near this observatory, a
beautiful place, there are people here from all states. It sure isn't lonesome traveling. Was pretty
hot in the desert but a cool air going so we didn't notice the heat so much. Had a nice thunder
shower last night, so we are resting today, will take an early start tomorrow morning. Enjoying
every moment. Mrs. J. Horche."

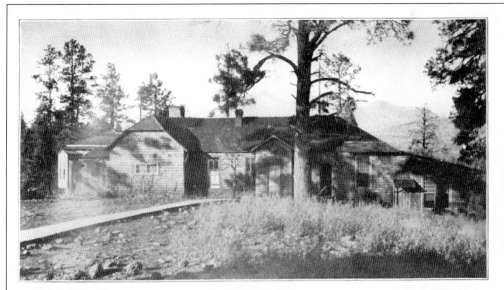

Director's Residence. Lowell Observatory, Flagstaff, Arizona.

UNDIVIDED BACK POSTCARD, C. 1910S–1920S. The Baronial Mansion was Percival Lowell's residence on Mars Hill. It was constructed in 1894 and had many additions in following years. It was literally just feet away from the observatory. This card demonstrates how wonderful a view they had of the San Francisco Peaks. The home was demolished in 1959.

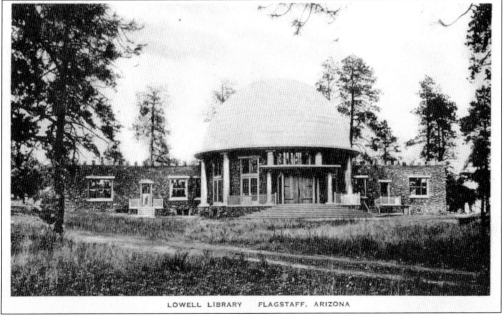

LOWELL LIBRARY FLAGSTAFF, ARIZONA

ALBERTYPE POSTCARD, 1936 POSTMARK, PUBLISHED BY CITY DRUG STORE. This building was constructed in 1915 and is known today as the Slipher Rotunda Building. Vesto Melvin Slipher was acting director of the observatory after Percival Lowell's death in 1916 and served as its director from 1926 until 1954. He is best known for his use of the spectrograph at the observatory that led to the discoveries of how fast the universe is expanding.

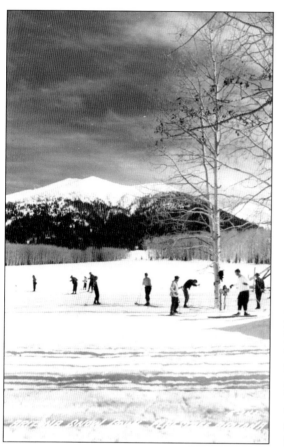

LEFT: REAL-PHOTO POSTCARD, 1941 POSTMARK; BELOW: REAL-PHOTO POSTCARD, C. 1940s. Arizona Snowbowl's official opening was in the winter of 1938. In the years leading up to 1933, skiing was only conducted in close proximity to town due to the road's condition heading north of town. Ole Solberg is credited with bringing the sport of skiing to Flagstaff. Ed Groesbeck was the person who helped bring organized skiing to Northern Arizona. In 1935, Ed Groesbeck was hired by the Coconino National Forest as a timber staff officer, which entailed managing timber sales and overseeing land use in the area. He used the Civilian Conservation Corps to build a road six miles up the southwest side of Agassiz Peak to an area known then as "Scissorbill Park." In 1939, the ski area was relocated to where the present-day slopes are at Hart Prairie, pictured in these postcards.

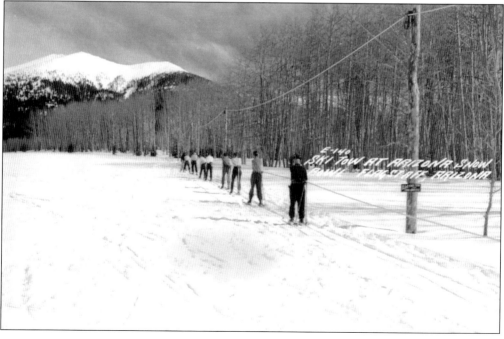

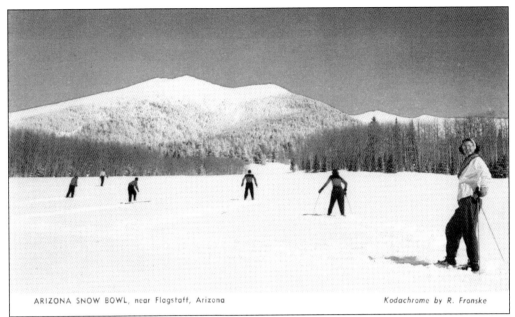

ARIZONA SNOW BOWL, near Flagstaff, Arizona *Kodachrome by R. Fronske*

PHOTOCHROME POSTCARD, C. 1940S–1950S. Snowbowl's success can be attributed to many clubs, organizations, and businesses that helped support the ski area. The 20-30 Club, which was made up of 20- and 30-year-olds, organized many popular festivals and carnivals associated with the winter. Flagstaff Ski Club was born out of this organization. Another club, the Ski Jacks, was formed at the Arizona State Teachers College in 1939.

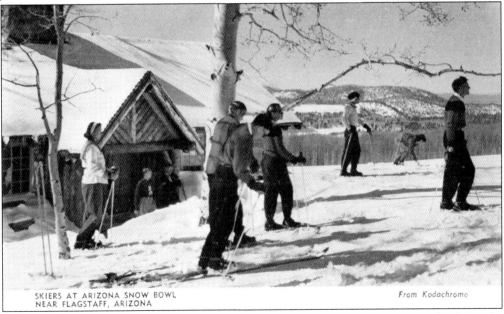

SKIERS AT ARIZONA SNOW BOWL
NEAR FLAGSTAFF, ARIZONA *From Kodachrome*

PHOTOCHROME POSTCARD, 1950 POSTMARK. The lodge pictured here was built by the Civilian Conservation Corp and finished in 1941. It featured a glass observation porch, a lounge, lunchroom, repair shop, lockers, and three fireplaces. It was known as the CCC Lodge. Unfortunately, in 1952 the lodge was destroyed by fire. An unsupervised fire in the lodge was to blame.

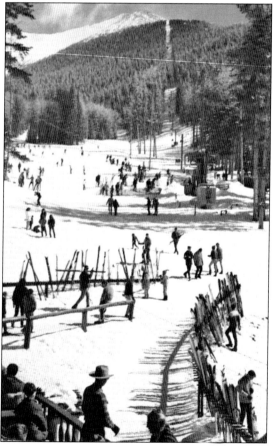

REAL-PHOTO POSTCARD, C. 1950S. This postcard illustrates the Shelter House at Arizona Snowbowl. This structure was erected right after the fire at the CCC Lodge and before construction of the new Agassiz Lodge. It was used as a temporary lodge and also housed the 3,000-foot rope tow engine, which supposedly was the world's longest at that time.

PHOTOCHROME POSTCARD, C. 1960S. By the 1955–1956 ski season, the basement and deck for the Agassiz Lodge was complete. The second story was erected the following year. Al Grasmoen (who bought the resort 10 years earlier) did much of the construction on his own and was helped by volunteers from the skiing community.

PHOTOCHROME POSTCARD, C. 1960S.
Snowbowl replaced its 3,000-foot rope tow with a poma lift in 1958. In 1962, Snowbowl was sold to Phoenix-based investors and the first chair lift was built to the top of Agassiz Peak. The name of the ski lift at the time was the Riblet Lift. The chair lift on Hart Prairie was constructed in 1982. The Hart Prairie lodge and Sunset chair lift were completed in 1983. The current Hart Prairie lift still uses the original Riblet Lift's chairs.

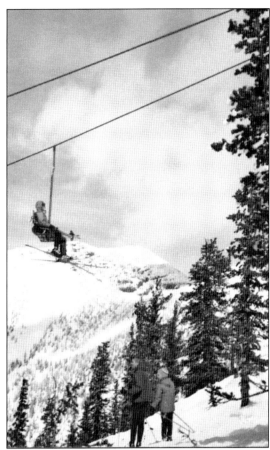

PHOTOCHROME POSTCARD, C. 1960S.
The current Agassiz Lift was relocated and installed in 1986. The entrance to the lift was moved closer to the lodge and the "drop off" was moved lower down the mountain due to high winds. It was also converted to a triple chair lift. This lift is also very popular during the summer months as Snowbowl's Scenic Skyride. (Postcard image courtesy Bradshaw Color Studios, Sedona, Arizona.)

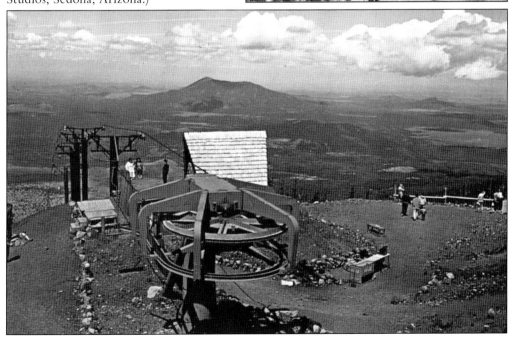

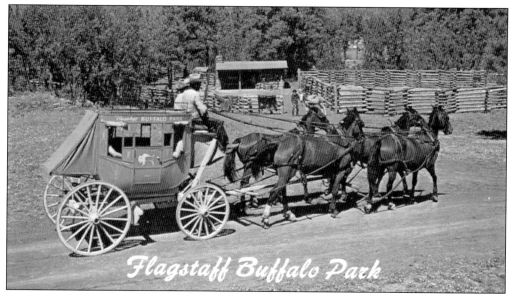

PHOTOCHROME POSTCARD, C. 1960S. Buffalo Park was established in 1963 and opened in April of the following year. The land was acquired by the city in 1958 from a trade with the Forest Service. Mayor Rollin W. Wheeler and the city council gave James Potter permission to start a wildlife park. The 163-acre, city-owned parcel was used as a tourist attraction and wildlife refuge for elk, deer, antelope, and buffalo. (Postcard image courtesy Bradshaw Color Studios, Sedona, Arizona.)

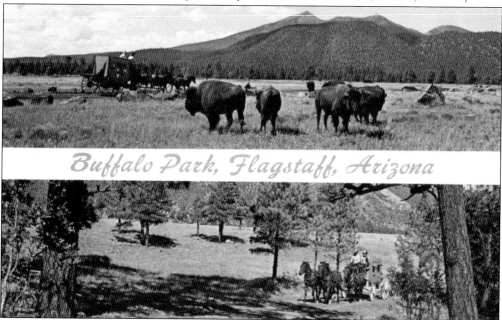

PHOTOCHROME POSTCARD, C. 1965. The park's entrance fee was only 50¢ per car. There were stagecoach rides with holdups, and some got to meet O.T. "Old Trapper" Gillette who told stories about the Wild West. Buffalo Park was short-lived. In October 1969, the park's five-year lease expired and it was told to remove the animals from the park. Serious debt was the culprit. Today, the park is used for recreation, nature trails, and an exercise course. (Postcard image provided courtesy Bradshaw Color Studios, Sedona Arizona.)

Six

RECREATIONAL RETREATS

229

FLAGSTAFF, ARIZONA
Gateway to the Hopi
and Navajo Reservations.

On Highway 66 near the junction of Highway 89,
direct route to Bryce and Zion National Parks.
Hunting-Fishing-Golfing-Swimming-Riding-Hiking-Camping-Ranching

The Grand Canyon..	90 MI.	San Francisco Peaks Highway	3 MI.
Petrified Forest......	110 "	Falls of the Little Colorado ...	35 "
Painted Desert.......	55 "	Tuba City Indian Agency.....	80 "
Meteor Crater.......	36 "	Moencopi, Hopi Indian Village	84 "
Sunset Mountain.....	13 "	Walnut Canyon Cliff Dwellings	9 "
Ice Caves, Lava Beds	13 "	Museum of Northern Arizona..	2 "
Lake Mary	9 "	Prehistoric Salt Mine.........	70 "
Mormon Lake.......	20 "	Tonto Natural Bridge.........	85 "
Oak Creek Canyon...	14 "	Rainbow Natural Bridge......	160 "
Montezuma Well.....	53 "	Pictograph Rocks............	10 "
Montezuma Castle ...	59 "	Hopi Mesas, Snake Dance.....	90 "
Wupatki Ruins	35 "	Jerome Mining District........	60 "
Elden Ruins.........	6 "	Arizona State Teachers College	½ "
Tuzigoot Ruins.......	60 "	Boulder Dam................	250 "
Dinosaur Canyon	61 "	Annual Indian Pow-Wow,	
Lowell Observatory..	1 "	6,000 Indians Participating	
Betatakin Ruins.....	100 "	Monument Valley...........	95 "

8A-H1943

CURT TEICH LINEN POSTCARD, C. 1940S. This postcard describes the various destinations
and their distances in relation to Flagstaff. The back reads, "Flagstaff is located on the main
line of the Santa Fe railroad and US Highway 66. Here is located the Lowell Observatory, the
Museum of Northern Arizona, and the Arizona State Teachers College. It is the gateway to the
greatest number of scenic and natural wonders of the world."

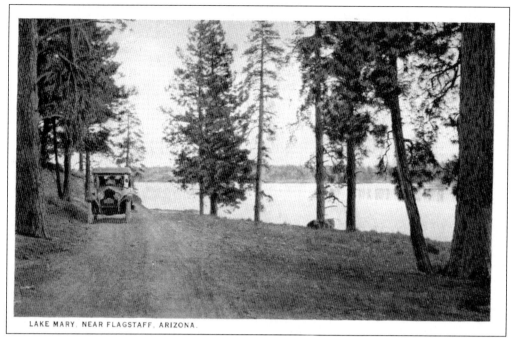

LAKE MARY, NEAR FLAGSTAFF, ARIZONA.

CURT TEICH POSTCARD, 1925 POSTMARK, PUBLISHED BY BABBITT BROTHERS TRADING COMPANY. The reverse of this postcard reads, "Lake Mary affords the finest fishing to be had in this section of the country and is only nine miles from Flagstaff." The lake was named after Tim Riordan's oldest daughter.

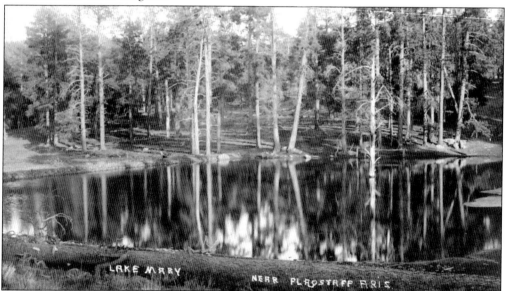

REAL-PHOTO POSTCARD, C. 1930S. Building a lake south of Flagstaff was the idea of Tim Riordan. In 1896, he suggested to a rancher in Clark Valley, Al Coverly, to build a small dam to catch water for his livestock. The idea worked so well that Tim Riordan bought the John Clark homestead and built another experimental dam in 1903. In 1904, he obtained a federal permit to build a permanent dam 200 feet long and 75 feet high. Soon thereafter, it became a very popular recreation area.

ABOVE: REAL-PHOTO CARSON POSTCARD, C. 1930S; BELOW: REAL-PHOTO POSTCARD, C. 1940S. Eventually, the lake was found to play an important role in supplying Flagstaff with its water supply. At the end of the 1930s there was anxiety about what to do about Flagstaff's water supply. A dependable water source was being investigated. Solutions considered included the damming of Fort Valley and the use of a dam in Switzer Canyon. Even though there was skepticism, damming Upper Lake Mary was agreed upon. The construction of the dam to form Upper Lake Mary was completed in 1941. The Lake Mary Water Treatment Plant was completed the same year. Not only is the water drawn directly from the lake, but it is thought to be recharging an aquifer located in the area.

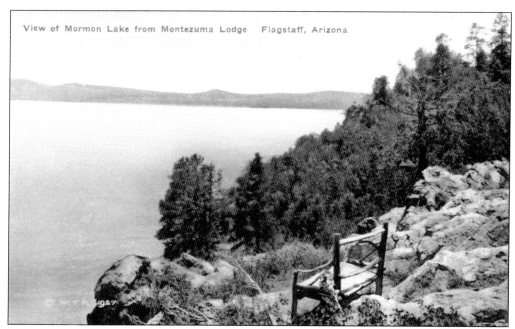

View of Mormon Lake from Montezuma Lodge Flagstaff, Arizona

ABOVE: ALBERTYPE HAND-COLORED POSTCARD, C. 1920S, PUBLISHED BY ROBERTSON'S NEWS STAND; BELOW: ALBERTYPE HAND-COLORED POSTCARD, C. 1920S, PUBLISHED BY BROWN'S NEWS STAND. Mormon Lake is located 29 miles southeast of Flagstaff. It was named for a Mormon settlement that used the land for a dairy farm. This area was established in 1878. It became a popular gathering place for ranchers and loggers working in the vicinity. Tombler's Lodge was built in 1924. The name changed to Mormon Lake Lodge in 1938 because of the change of ownership. The lodge changed hands a few more times before being destroyed by fire on July 4, 1974. The lodge was rebuilt immediately by local ranchers and cowboys and was open by Labor Day that same summer.

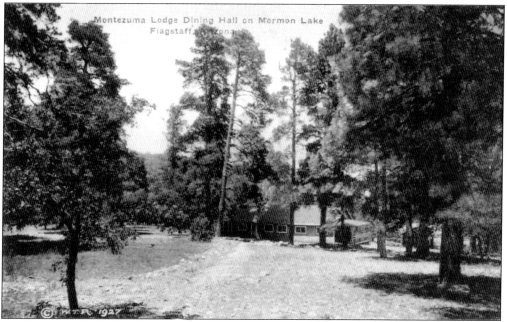

Montezuma Lodge Dining Hall on Mormon Lake
Flagstaff, Arizona

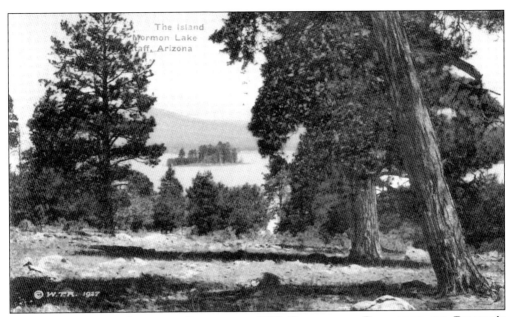

ALBERTYPE HAND-COLORED POSTCARD, 1928 POSTMARK, PUBLISHED BY BROWN'S NEWS STAND. The letter on the reverse reads, "Got a ride thru here today. All the land around here is under government control. So many Indians here, real ones, and a lot of cowboys. Got a look at the painted desert from a distance. Ten of our boys went over Grand Canyon in a plane at $25 each. I didn't go. Dad."

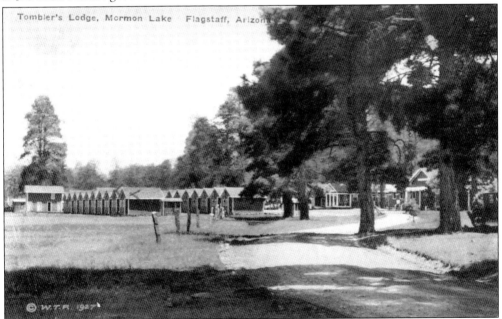

ALBERTYPE HAND-COLORED POSTCARD, 1928 POSTMARK, PUBLISHED BY BROWN'S NEWS STAND. The letter on the back of this card reads, "Dear Folks: Marked cabins are where we are staying. Pete is on his vacation. Edira and Stanley have been with us. We took them to the Canyon. It's beautiful. Pete and Stanley are fishing tonite. It will soon be time to go to Chicago. Wish you folks were here. Edira could have a head ache from laughing too much. Caroline."

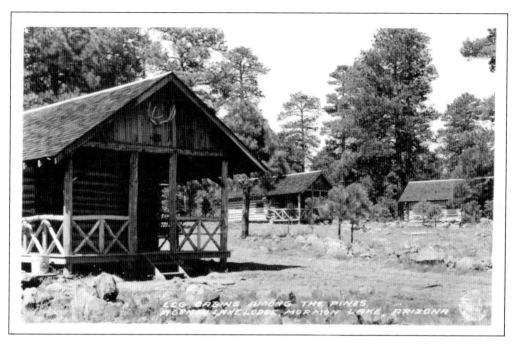

ABOVE: REAL-PHOTO POSTCARD, C. 1930S–1940S; BELOW: REAL-PHOTO CARSON POSTCARD, C. 1930S. Mormon Lake was and still is a place for families to enjoy the outdoors. The area is known for its wildlife. Large herds of elk roam the forests, antelope graze in the grasslands, and bald eagles hunt on the lake. Great fishing is to be had in the lake as well. The lodge houses a restaurant and saloon. Rodeo events have been a big draw for many years at Mormon Lake. During winter months, cross-country skiing is a popular activity in the area. Today, Mormon Lake is home to many full-time residents.

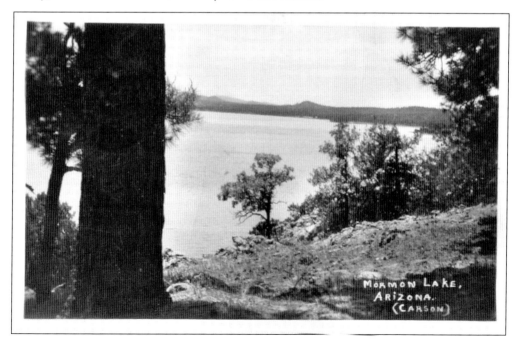

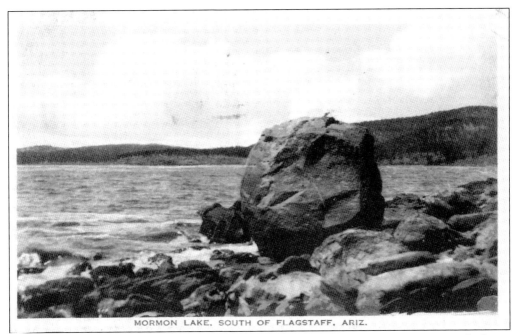

MORMON LAKE, SOUTH OF FLAGSTAFF, ARIZ.

ALBERTYPE POSTCARD, 1923 POSTMARK, PUBLISHED BY THE NEWS STAND. The letter on the reverse of this postcard reads, "Back out of the desert again. Sure see a bunch of Ohio cars going thru to California for the winter. Having cold weather here, it froze ice last night. Leaving for Texas today. Give my best to all. Earl."

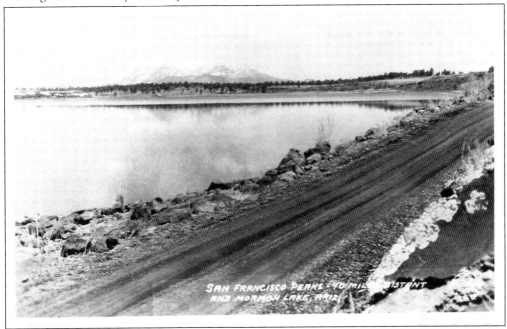

SAN FRANCISCO PEAKS - 40 MILES DISTANT
AND MORMON LAKE, ARIZ.

REAL-PHOTO POSTCARD, C. 1930s–1940s. Mormon Lake, when full, covers a surface area of about 12 square miles. It is the largest natural lake in Arizona. The lake receives its water from runoff during monsoon rains and snowmelt from the surrounding forest. During severe drought, the lake recedes and sometimes has even completely dried up in the past.

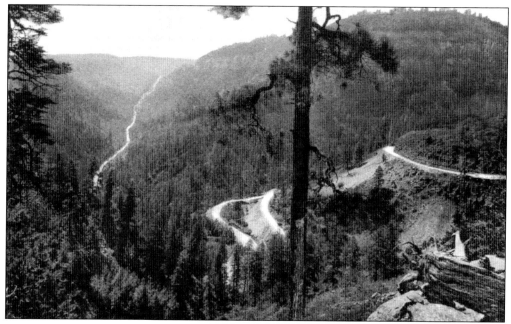

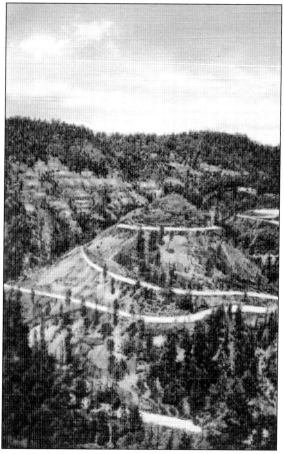

ABOVE: ALBERTYPE HAND-COLORED POSTCARD, C. 1930S–1940S; LEFT: CURT TEICH LINEN POSTCARD, C. 1940S.
The title of the above postcard is "Highway 79, Hairpin Curve through Oak Creek Canon near Flagstaff, Ariz." State Route 79 was created in 1927 by the Arizona Department of Transportation. The plan at the time was to have this road lead from Prescott to Flagstaff. In 1935, the construction to Flagstaff was complete and by 1938 the entire route had been paved. In 1941, the highway changed its designation from State Route 79 to US 89A. Before I-17 was created, the only route north to Flagstaff was through Prescott. US 89A was redesignated SR 89A in 1993. The opposite side of the lower postcard reads, "En-route from Flagstaff to Prescott, Arizona, the highway drops 2,000 feet in five minutes, negotiating several switchbacks during the descent."

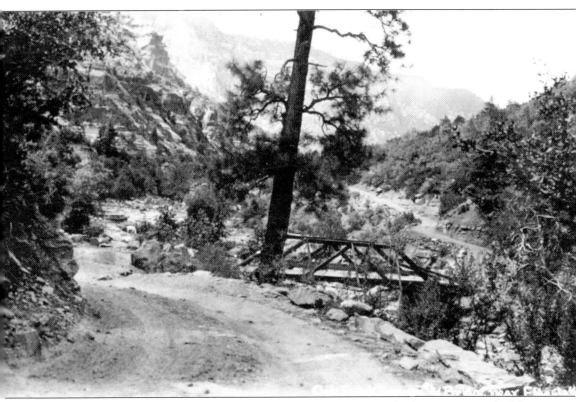

REAL-PHOTO POSTCARD, C. 1920S. In 1914, Jess Purtymun was leading a crew to build a road north in Oak Creek Canyon and Frank L. Pendley was building it south. The two crews worked toward each other until they met at Oak Creek Falls and constructed a bridge. In 1917, that bridge burned and another bridge (shown here) was erected the following year. Frank L. Pendley is best known for having the Pendley Homestead in the area, better known today as Slide Rock State Park. He arrived in the canyon in 1907 and acquired the property in 1910 under the Homestead Act. He developed an apple orchard in 1912 while using a unique irrigation method. With the completion of the road in 1914, tourism in the area began to increase. In 1933, Pendley built cabins on his property to attract tourists. Today, Slide Rock State Park is the most visited spot along Oak Creek Canyon. It is known for its slippery creek bottom that allows enthusiasts to slide down a water chute. Both the US Forest Service and the Arizona State Parks manage it.

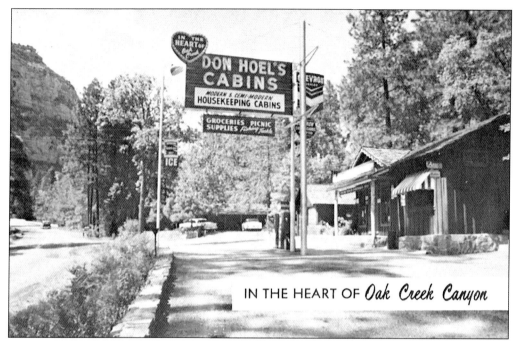

IN THE HEART OF *Oak Creek Canyon*

ADVERTISING POSTCARD, C. 1960s. In 1945, Don Hoel and his wife, Nita, started a lodging business "In the Heart of Oak Creek Canyon" named Don Hoel's Cabins. It was located 19 miles south of Flagstaff. It had many amenities including a grocery store, Indian jewelry, tackle, licenses, and even a Chevron gas station. They also boasted a number of activities: fishing, hunting, horseback riding, hiking, swimming, and photography. The cabins closed in 2006.

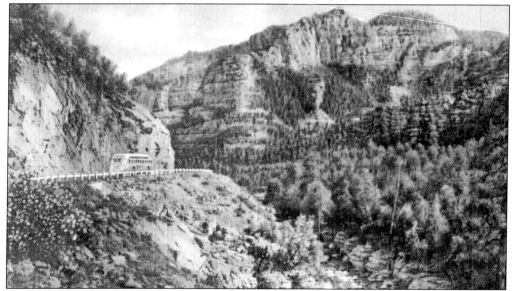

CURT TEICH LINEN POSTCARD, 1939 POSTMARK. The back of this postcard reads: "Located on Highway 79, twenty miles south of Flagstaff, Oak Creek Canyon is one of the most scenic trips of the Southwest." The letter written on the reverse reads, "Dear Danny, No picture can be as beautiful as this canyon really is. I drove thru it again today—the autumn colors are ripe. . . . Regards to Tommy, Dad."

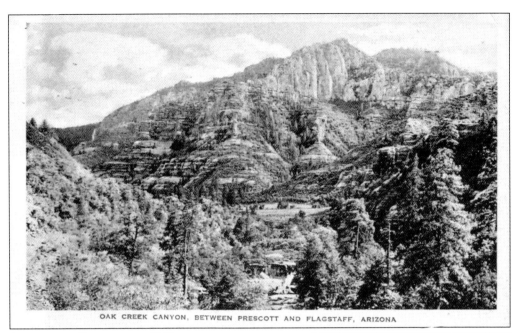

OAK CREEK CANYON, BETWEEN PRESCOTT AND FLAGSTAFF, ARIZONA

ALBERTYPE POSTCARD, 1931 POSTMARK. The letter on this postcard reads as follows: "July 8th, Wed. —Mileage today 258 miles. Stopped many times to turn glasses on scenes like this. Wonderful coloring and fantastic shapes. Most beautiful we have seen yet. Hard on machine and driver. Roads narrow and steep . . . Love from Anna."

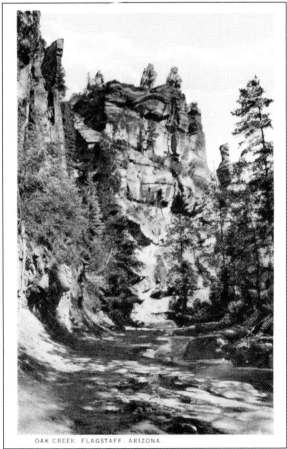

OAK CREEK FLAGSTAFF ARIZONA

CURT TEICH POSTCARD, C. 1920s–1930s, PUBLISHED BY BABBITT BROTHERS TRADING COMPANY. Many rock formations were named all along Oak Creek Canyon. They were named after animals, mythical creatures, or whatever they may resemble. This postcard reads, "Here you see the 'El Capitan' of Oak Creek which rises to an altitude of 1200 feet."

79

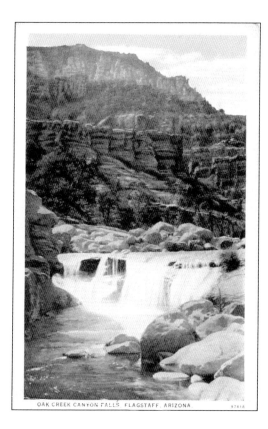

OAK CREEK CANYON FALLS, FLAGSTAFF, ARIZONA

CURT TEICH POSTCARD, 1929 POSTMARK, PUBLISHED BY BABBITT BROTHERS TRADING COMPANY. The description on this postcard reads, "While the Grand Canyon is more spectacular, Oak Creek offers more charm and intimate beauty than any of the many canyons of Arizona and is only forty minutes ride over good roads from Flagstaff."

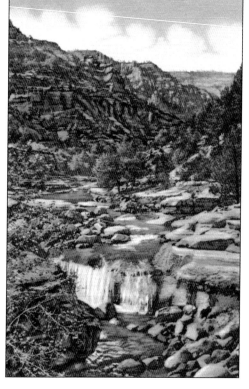

CURT TEICH LINEN POSTCARD, C. 1940S. "A most delightful resort for camping, fishing and hunting," proclaims this postcard. "The towering cliffs with their gorgeous coloring, the rushing stream at the bottom of the heavily wooded canyons, make of it the most bewitching spot in Northern Arizona."

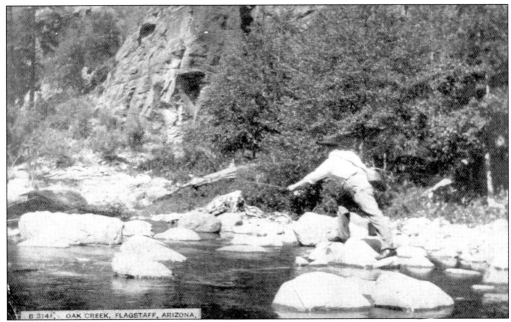

B 3141. OAK CREEK, FLAGSTAFF, ARIZONA.

ABOVE: DIVIDED BACK POSTCARD, 1911 POSTMARK, PUBLISHED BY THE HUNTER DRUG COMPANY; BELOW: ALBERTYPE POSTCARD, C. 1920S–1930S, PUBLISHED BY O.B. RAUDEBAUGH NEWS STAND. Oak Creek Canyon is about 12 miles long and ranges in width from 1 to 2.5 miles. The depth ranges from 800 to 2,000 feet. The west rim of the canyon is slightly higher in elevation. The source of Oak Creek is fed by naturally occurring artesian springs and also from runoff from snowmelt in spring and monsoon rains during the summer. Fishing for rainbow and brown trout has been a popular activity here for many years. A popular place to fish today is The Trout Farm, located along the banks of Oak Creek, three and a half miles north of Sedona. It has been in existence since 1952.

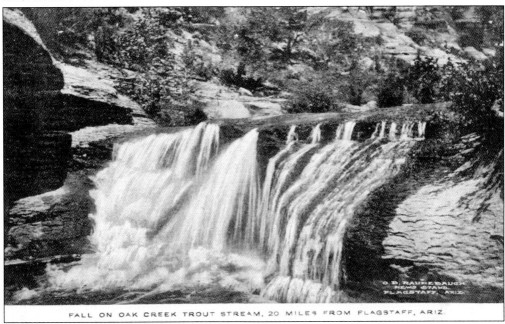

FALL ON OAK CREEK TROUT STREAM, 20 MILES FROM FLAGSTAFF, ARIZ.

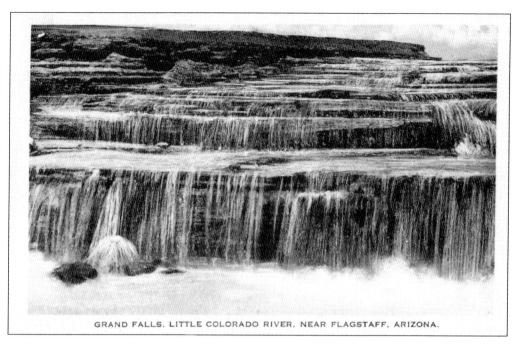

GRAND FALLS. LITTLE COLORADO RIVER, NEAR FLAGSTAFF, ARIZONA.

ABOVE: ALBERTYPE POSTCARD, C. 1930S–1940S; BELOW: REAL-PHOTO POSTCARD, C. 1920S–1930S. Grand Falls is located on the Little Colorado River, northeast of Flagstaff on the Navajo Indian Reservation. These falls are 185 feet high and only run during the spring melt and the heavy monsoon rains. They are known for their chocolate, sediment rich falls. They were created 150,000 years ago, during a lava flow from the Merriam Crater. This created a natural dam, forcing the river to make a sharp detour, creating the deep canyon that is present today.

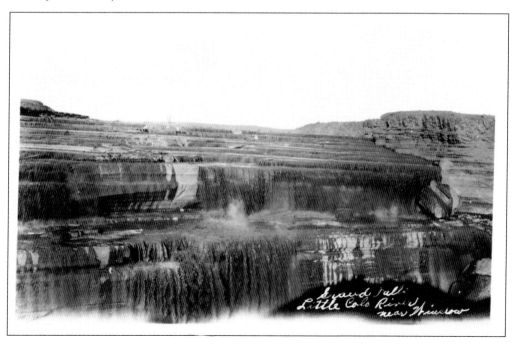

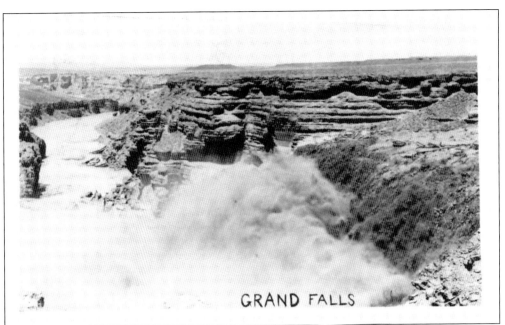

GRAND FALLS

ABOVE: REAL-PHOTO POSTCARD, C. 1920S–1930S; BELOW: REAL-PHOTO CARSON POSTCARD, C. 1930S. The Little Colorado River is one of the two major tributaries of the Colorado River in Arizona. There are many springs that help the flow the closer the river gets to the Grand Canyon. It runs over a length of 315 miles. The river starts in the White Mountains of central eastern Arizona as two forks, which merge together near the town of Greer. Then it meanders northeast through the state and into the Painted Desert and the Navajo Indian Reservation. Grand Falls is the starting point where steep, deep canyons start to evolve. It then passes through the town of Cameron and eventually empties into the Colorado River in the Grand Canyon.

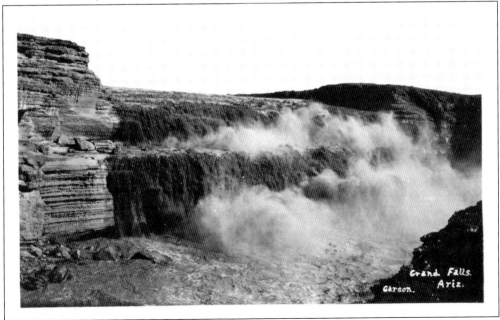

Grand Falls.
Carson. Ariz.

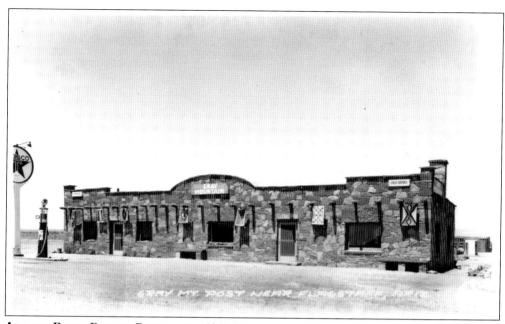

ABOVE: REAL-PHOTO POSTCARD, 1941 POSTMARK; BELOW: REAL-PHOTO POSTCARD, C. 1930s–1940s. Traveling north to the Navajo Indian Reservation was seen as exploring a different country. When heading north on US Route 89 out of Flagstaff, the pine forests give way to the grasslands and high desert of the reservation. Driving through this area, trading posts are seen sporadically. These trading posts would barter for products such as flour, sugar, tobacco, and dry goods for Native American crafts such as rugs, baskets, and jewelry. They would also sell their crafts to tourists passing through. These postcards show the small town of Gray Mountain. Located about 50 miles north of Flagstaff, the area boasts a trading post, a gas station, and a few motels. The postcard below shows the view from the town along US Route 89 of the San Francisco Peaks.

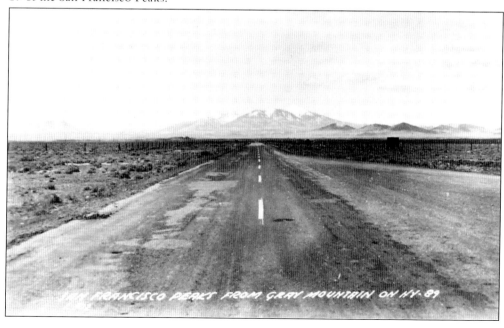

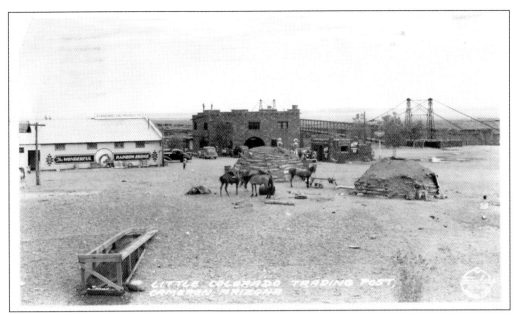

REAL-PHOTO POSTCARD, 1939 POSTMARK. The Cameron Trading Post was established in 1916. The town of Cameron receives its name from Ralph Cameron, a former US senator, businessman, and miner. He built the first trails into the Grand Canyon in 1899, with the intention of using it for his mines. The trail eventually came under the jurisdiction of the National Park Service in 1928 and became the most popular hiking trail in the Grand Canyon, the Bright Angel Trail.

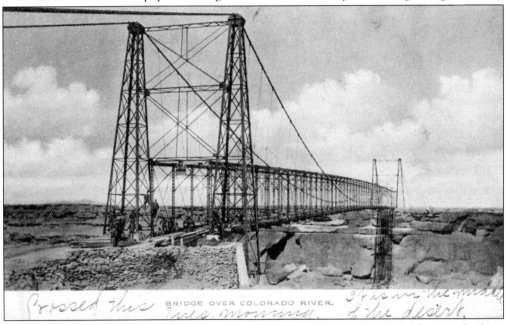

ALBERTYPE POSTCARD, 1915 POSTMARK. The Cameron Suspension Bridge was built in 1911 and spans the Little Colorado River east of the Grand Canyon entrance. This bridge was constructed because upstream at Tanner's Crossing, it became too dangerous to cross due to quicksand and flooding. The Mormon Trail from Utah crossed here to reach settlements in Arizona. Tanner's Crossing was named after Seth Tanner, a prospector from Tuba City.

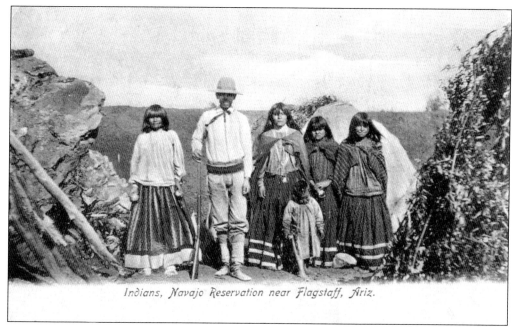

Indians, Navajo Reservation near Flagstaff, Ariz.

ALBERTYPE ADVERTISING POSTCARD, C. 1920S–1930S. The Navajo Nation occupies 27,000 square miles in the states of Arizona, Utah, and New Mexico. The "Long Walk of the Navajo" was the deportation of the Navajo people from what is now Arizona to eastern New Mexico in 1864. The Navajo Indian Reservation was established according to the Treaty of 1868. In 1923, a tribal government was established to help delegate and lease this area to American oil companies.

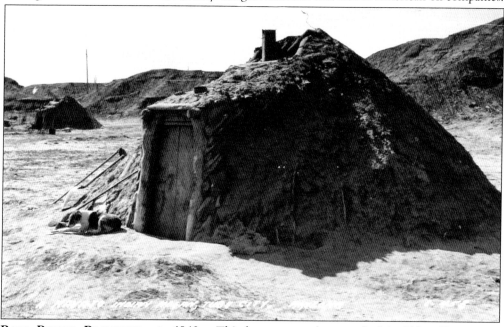

REAL-PHOTO POSTCARD, C. 1940S. This hogan was photographed in Tuba City. It is a traditional home of the Navajo people. The Mormons founded the town of Tuba City in 1872. The Navajo, Hopi, and Paiute Indians were attracted to this city because of the natural springs it possessed. In 1956, Tuba City became popular for the Uranium deposits that were found there.

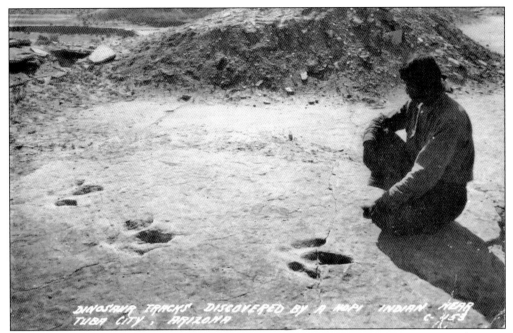

REAL-PHOTO POSTCARD, 1946 POSTMARK. These dinosaur tracks are found near Tuba City. The message on the postcard reads, "Cameron, Friday 12th, 1946. Broke down in the desert 50 miles from El Tovar—we're towed here—population 75—good people. Love, Elsie and Art."

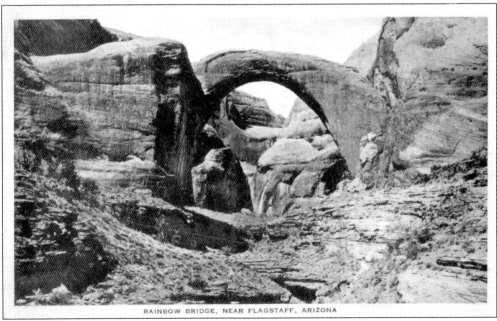

ALBERTYPE POSTCARD, 1929 POSTMARK, PUBLISHED BY BROWN'S NEWS STAND. Located on the border of Arizona and Utah in the Glen Canyon National Recreational Area, Rainbow Bridge National Monument is the largest natural bridge in the world. Native Americans who considered the site sacred knew of the bridge's existence for centuries. It was not until 1909 that it was highly publicized. A year later, President Taft visited the monument.

CURT TEICH LINEN POSTCARD, C. 1940S. Window Rock is the administrative capital of the Navajo Nation and gets it name from the hole in the 200-foot-high sandstone hill. In 1936, John Collier, (Commissioner of Indian Affairs at the time) selected Window Rock for the Navajo Center Agency. The back reads, "Looking thru 'Tse Gah ho Tzun' (the hole in the rock) one gazes upon the immense expanse of erosions among which are located the buildings comprising the 'Indian Capital,' also called 'Nee Alneeng,' the Navajo word meaning center. The huge Administration Building is shown in the foreground, the Council Hogan on the right, while a portion of the employees quarters are seen in the distance." Today, a Veterans Memorial is there to honor the many Navajos who served in the US military. Many Navajo soldiers are recognized for their role as Code Talkers during World War II. They used the Navajo language to create a code that was never deciphered by the enemy.

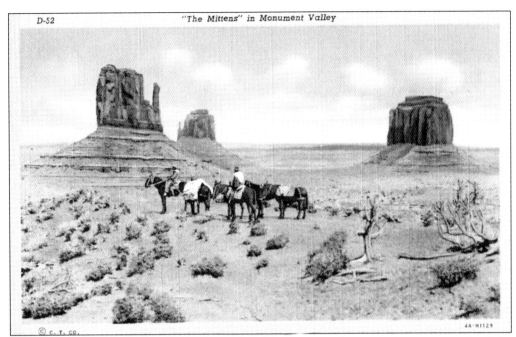

Curt Teich Linen Postcard, c. 1930s–1940s. In 1938, the movie *Stagecoach* starring John Wayne and John Ford brought Monument Valley to the attention of tourists and film directors. The impressive sandstone formations of buttes, spires, and towers are awe-inspiring. Located in the Four Corners region of the Southwest, its landscape views are like no other.

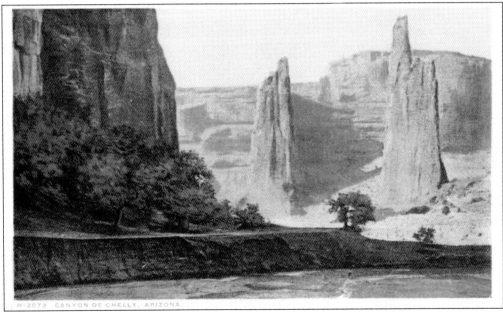

Divided Back, "Phostint" Postcard, c. 1900s–1920s, Made by Detroit Publishing Company. Pres. Herbert Hoover established Canyon De Chelly National Monument on April 1, 1931, to preserve the important archaeological resources that the canyon possessed. It is located on the Navajo Indian Reservation in Northeastern Arizona. Natural water sources and fertile soil helped to sustain life for thousands of years in the canyon.

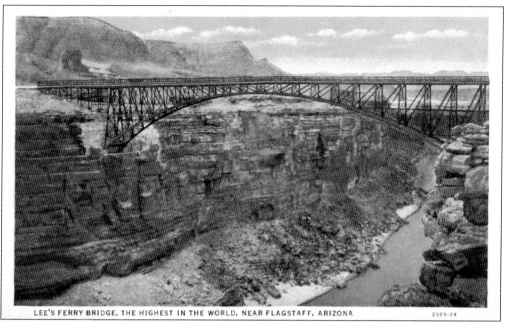

LEE'S FERRY BRIDGE, THE HIGHEST IN THE WORLD, NEAR FLAGSTAFF, ARIZONA 2505-29

CURT TEICH POSTCARD, C. 1930S, PUBLISHED BY BABBITT BROTHERS TRADING COMPANY. In the 1870s, Mormon pioneers from Utah began to expand their settlements into Arizona. Lees Ferry, established in 1873, became an important route in this area. John D. Lee was the operator of the ferry and a Mormon settler. The ferry provided the only crossing until the Grand Canyon Bridge was erected. Lees Ferry Bridge was another name sometimes used for Grand Canyon Bridge.

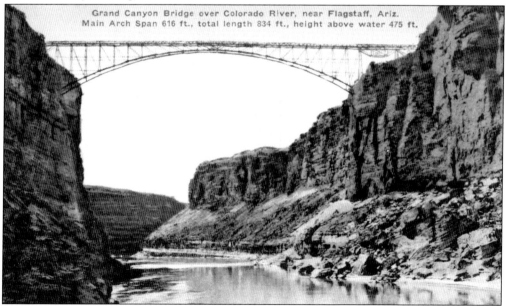

Grand Canyon Bridge over Colorado River, near Flagstaff, Ariz.
Main Arch Span 616 ft., total length 834 ft., height above water 475 ft.

ALBERTYPE HAND-COLORED POSTCARD, C. 1930S, PUBLISHED BY ROBERTSON'S NEWS STAND. Grand Canyon Bridge opened to traffic on January 12, 1929. Five years later, the name was changed to Navajo Bridge after a large debate in the Arizona legislature. The old bridge eventually became a safety concern, and the new Navajo Bridge was completed in 1995.

Seven

NATIONAL AND
STATE PARKS

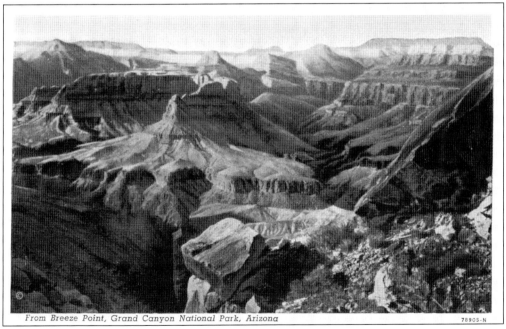

From Breeze Point, Grand Canyon National Park, Arizona 78905-N

CURT TEICH POSTCARD, C. 1930S–1940S, PUBLISHED BY VERKAMP'S. The Grand Canyon was the primary destination for many tourists passing through Flagstaff. Pres. Theodore Roosevelt first designated the Grand Canyon as a game preserve on November 28, 1906. Later, he designated the preserve as a national monument on January 11, 1908. It was not until Pres. Woodrow Wilson signed it into law on February 26, 1919, that the Grand Canyon became a national park.

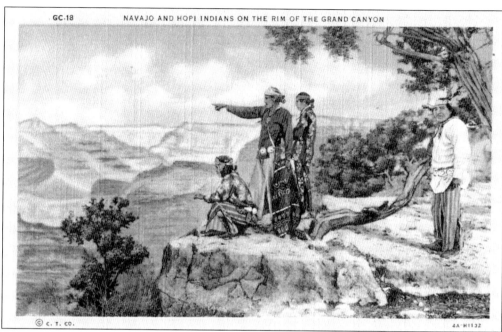

© C. T. CO. 4A-H1132

CURT TEICH LINEN POSTCARD, C. 1930S–1940S. Many Native Americans were paid by the Fred Harvey Company to stage ceremonies and dances. They would also demonstrate how they produced certain crafts such as baskets, rugs, blankets, pottery, and jewelry. Some were hired to live a traditional lifestyle within the park. Tourists were made to think that these people were always here from the beginning.

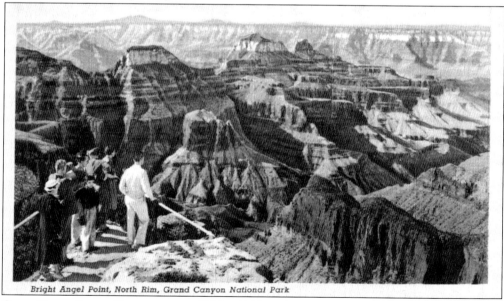

Bright Angel Point, North Rim, Grand Canyon National Park

CURT TEICH LINEN POSTCARD, C. 1930S–1940S. The message on the back of this card reads, "The North Rim of the Grand Canyon at this point is about 1,400 feet higher in elevation than the opposite rim, and presents the most amazing view of this stupendous chasm. The Grand Canyon is approximately 13 miles across, and from Bright Angel Point on the North Rim one may see not only the Canyon itself, but the San Francisco Peaks far beyond."

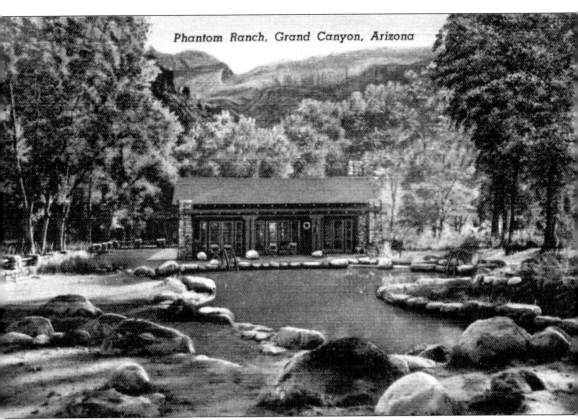

Phantom Ranch, Grand Canyon, Arizona

CURT TEICH LINEN POSTCARD, 1950 POSTMARK, PUBLISHED BY VERKAMP'S. The message reads, "At the very bottom of Grand Canyon lies Phantom Ranch. Here are found modern over-night accommodations for the visitor who wishes to spend some time within the depths of one of the world's seven natural wonders." Pres. Theodore Roosevelt traveled to this site during a hunting expedition in 1913. Because of this visit, the site at the time was known as Roosevelt Camp. The name changed in 1922 when the Fred Harvey Company acquired the concession for the camp and hired architect Mary Colter to design more permanent lodging. Mary Colter is responsible for the change of name to Phantom Ranch. In the 1930s, the Civilian Conservation Corps made numerous improvements to the ranch and the trails leading to it. The CCC built the pool pictured in the postcard. With so many tourists visiting the area, there was concern about vandalism and how sanitary the pool was. In 1971 the pool was backfilled with dirt and rocks. In 1969, the National Park Service found it necessary to issue permits to stay overnight.

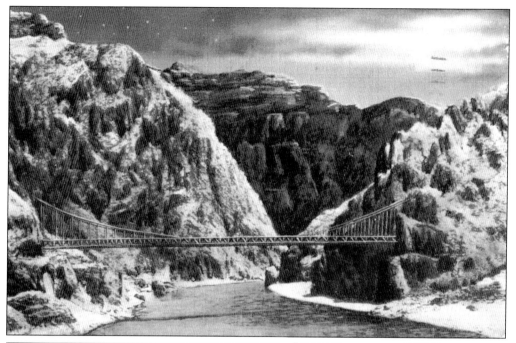

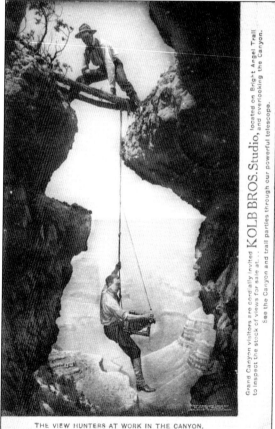

KOLB BROS. Studio, located on Bright Angel Trail and overlooking the Canyon.

Grand Canyon visitors are cordially invited to inspect the stock of views for sale at...

See the Canyon and trail parties through our powerful telescope.

THE VIEW HUNTERS AT WORK IN THE CANYON.

LINEN POSTCARD, 1938 POSTMARK. The title of this postcard is "Foot Bridge Over Colorado River At The Bottom Of Grand Canyon By Moonlight." The first means of crossing the Colorado River was the use of a cable tram, built by David Rust. In 1921, the tram was replaced by a wooden suspension bridge. This bridge allowed mules to cross but it was narrow and unstable in the wind. The Kaibab Suspension Bridge was built by the National Park Service in 1928.

DIVIDED BACK POSTCARD, 1911 POSTMARK. Brothers Emery and Ellsworth Kolb started a photography business in 1903 at the Grand Canyon. They took photographs of visitors on mule rides down Cameron's trail (now Bright Angel Trail) and charged a fee. In 1912, they completed a boat trip down the Colorado River. They were the first to record their adventures on film. Ellsworth left the business in 1924, and Emery kept the operation going until his death in 1976.

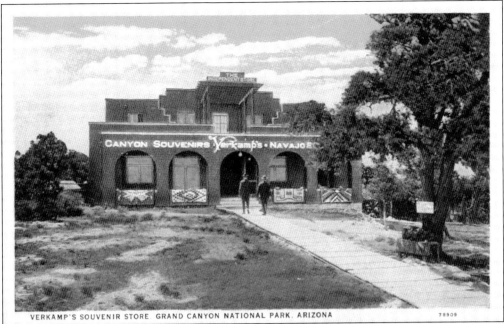

VERKAMP'S SOUVENIR STORE. GRAND CANYON NATIONAL PARK. ARIZONA 78909

ABOVE AND BELOW: CURT TEICH POSTCARD, C. 1930S, PUBLISHED BY VERKAMP'S.
John G. Verkamp was one of the first entrepreneurs of the Grand Canyon. He started out by selling curios to visitors out of a tent near the Bright Angel Trail in 1898. A few years later, he constructed Verkamp's Curios (above), the doors of which opened in 1906. It is located just a few steps from the rim. It specialized in handcrafts done by Native Americans and was especially known for Navajo rugs. The reverse of the above postcard reads, "Visit this store and see the largest and most famous PAINTING of the Grand Canyon. . . . Done by Louis Akin." The store closed in September 2008 and the family sold the building to the National Park Service in 2009.

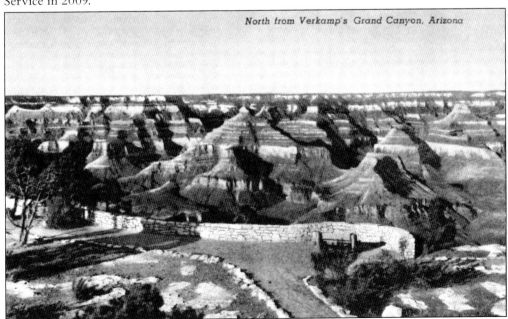

North from Verkamp's Grand Canyon, Arizona

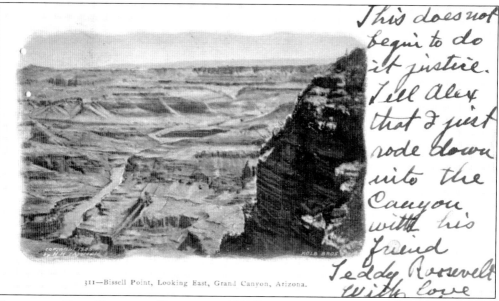

This does not begin to do it justice. Tell Alex that I just rode down into the Canyon with his friend Teddy Roosevelt with love

311—Bissell Point, Looking East, Grand Canyon, Arizona.

UNDIVIDED BACK EMBOSSED POSTCARD, 1911 POSTMARK. Pres. Theodore Roosevelt visited the Grand Canyon on numerous trips to hunt and enjoy the views. He was a major proponent of the preservation of the Grand Canyon. The letter states, "This does not begin to do it justice. Tell Alex that I just rode down into the Canyon with his friend Teddy Roosevelt. With love, Judd."

The Best for the Money — Cabins, Water, Showers and Wood to Fit the Stove

Only Independent Camp and Store in Grand Canyon National Park D-2238

ADVERTISING POSTCARD, C. 1930s–1940s. Rowe's Well Camp was named after Sanford Rowe, a prospector around 1890. He made a handful of mining claims but the only mineral he found was water. This lodging was only 3.5 miles from the park. On the back of the postcard is a map of the Grand Canyon. Written on the back is the following: "Compliments–'Rowe's Well Camp' The Independent Concern of the Grand Canyon National Park. Cabins 75 Cents. Ed. Hamilton, Boss." The park did not like independent businesses. This was one of the last to survive.

RIGHT: DIVIDED BACK POSTCARD, 1918 POSTMARK, PUBLISHED BY B. HOCK; BELOW: CURT TEICH POSTCARD, 1928 POSTMARK, PUBLISHED BY BABBITT BROS. TRADING COMPANY. Theodore Roosevelt designated Montezuma Castle as a national monument on December 8, 1906. It is located about 50 miles south of Flagstaff. When the multistory cliff dwelling was discovered in the 1860s, it was improperly named Montezuma on the belief that it had a direct connection to the Aztec emperor. The five-story structure once housed approximately 50 people of the Sinagua Indians. The dwellings were carved into limestone on a high cliff. Access to these ruins was permitted until 1950, when it was realized that climbing in and around the site created serious damage to the dwelling.

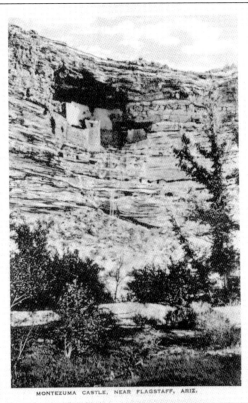

MONTEZUMA CASTLE, NEAR FLAGSTAFF, ARIZ.

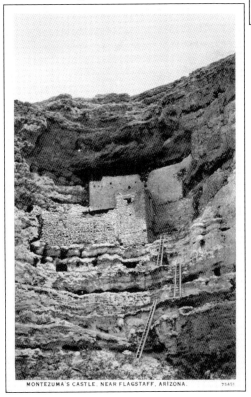

MONTEZUMA'S CASTLE, NEAR FLAGSTAFF, ARIZONA. 75451

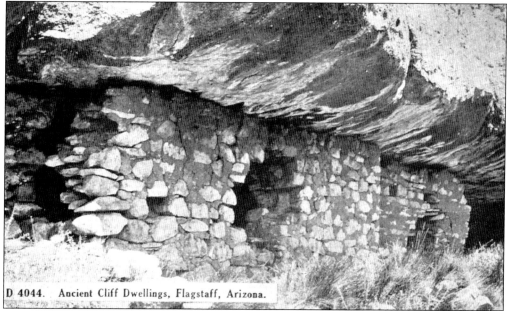

D 4044. Ancient Cliff Dwellings, Flagstaff, Arizona.

ABOVE: DIVIDED BACK POSTCARD, 1912 POSTMARK; BELOW: ALBERTYPE POSTCARD, 1918 POSTMARK. Walnut Canyon is named after the Arizona Black Walnut, which can be found there. This steep and deep canyon was carved by rushing floodwaters until a dam was built upstream in 1904. There are approximately 300 rooms, about 80 of which were used for shelters, and were thought to house several hundred people. Looting of the cliff dwellings became a serious issue when pothunters began dynamiting the walls. Fr. Cyprian Vabre, a Catholic priest from Flagstaff, was one of the first to fight against this practice. Many of the locals agreed and lobbied the federal government to protect it. Walnut Canyon became a national monument in 1915 under Woodrow Wilson.

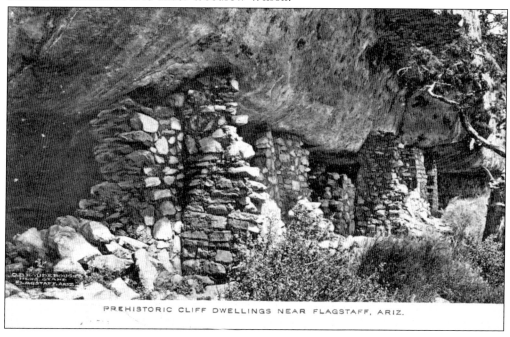

PREHISTORIC CLIFF DWELLINGS NEAR FLAGSTAFF, ARIZ.

Foresters Cabin, Walnut Canyon, Flagstaff, Ariz.

UNDIVIDED BACK POSTCARD, PRE-1910. The "Forester's Cabin" was built in 1904. The Forest Service hired William H. Pierce (Walnut Canyon's first ranger) to help protect the area from looters. Pierce and his wife, Mattie, used the tent pictured in the postcard while the cabin was being built. There were stories of the couple deterring visitors from digging in the archeological sites while offering for sale the artifacts they had found there.

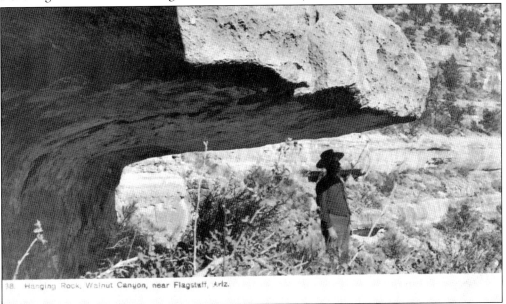

38. Hanging Rock, Walnut Canyon, near Flagstaff, Ariz.

UNDIVIDED BACK POSTCARD, PRE-1910. The walls of the canyon consist of Kaibab limestone and Coconino sandstone. The creek helped sculpt the limestone to create overhanging ledges, great shelter for its later inhabitants. The two sides of Walnut Canyon couldn't be any more different from each other. The south-facing walls tend to be warmer and more desert-like, while the north-facing slopes are more shady, cool, and moist.

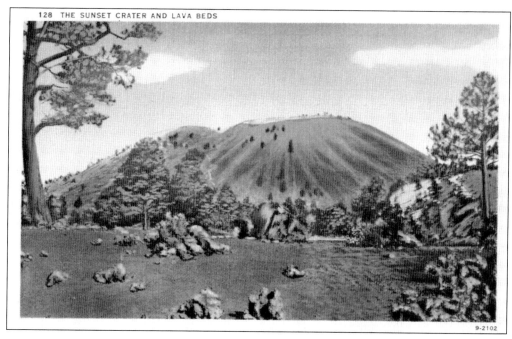

9-2102

ABOVE: DIVIDED BACK LINEN POSTCARD C. 1930S–1940S; BELOW: DIVIDED BACK POSTCARD, 1917 POSTMARK. Sunset Crater is a cinder cone located northeast of Flagstaff. It is the youngest cone in the San Francisco volcanic field. It first erupted around 1064 AD, and the last major eruption occurred around 1200 AD. The colors of red and orange from the cinders along the rim are what led John Wesley Powell to give it its name in 1885. In the late 1920s, a Hollywood film company attempted to detonate explosives inside Sunset Crater in order to simulate an eruption and landslide. This idea disturbed many and led to the creation of Sunset Crater Volcano National Monument by Pres. Herbert Hoover in 1930.

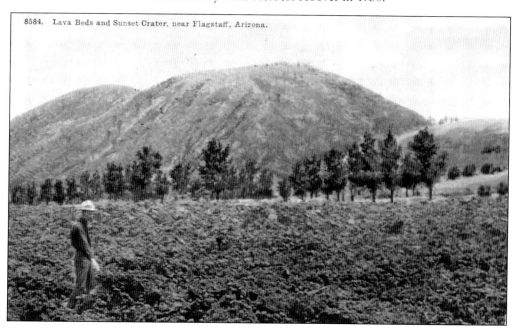

8584. Lava Beds and Sunset Crater, near Flagstaff, Arizona.

Cinder Hills at Sunset Mountain.

DIVIDED BACK POSTCARD, C. 1910S–1920S, PUBLISHED BY WILL MARLAR PHARMACY.
In the 1960s, the Astrogeology branch of the US Geological Survey in Flagstaff created an artificial crater field to prepare astronauts for upcoming lunar missions. They recreated a lunar landscape by setting off charges to make craters of the proper size. The location was just south of Sunset Crater.

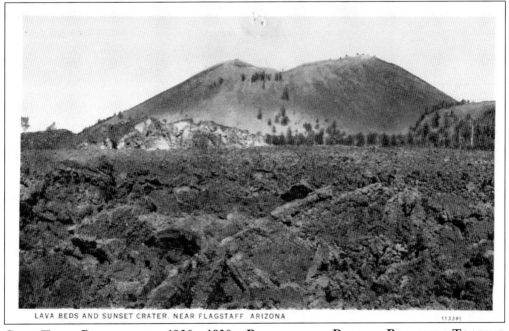

LAVA BEDS AND SUNSET CRATER, NEAR FLAGSTAFF, ARIZONA

CURT TEICH POSTCARD, C. 1920S–1930S, PUBLISHED BY BABBITT BROTHERS TRADING COMPANY. The reverse reads, "Sunset Mountain, the crater of an extinct volcano whose peak always appears as if flooded with sunshine, the ice cave and the vast beds of lava around its base are visited by thousands of tourists each year."

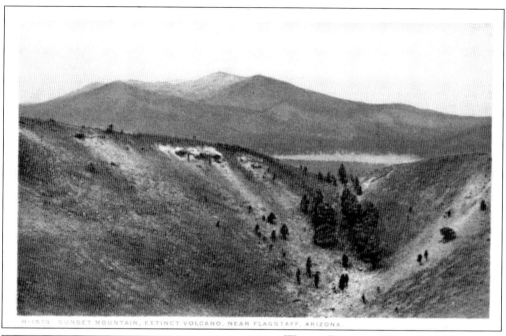

H-1579 SUNSET MOUNTAIN, EXTINCT VOLCANO, NEAR FLAGSTAFF, ARIZONA.

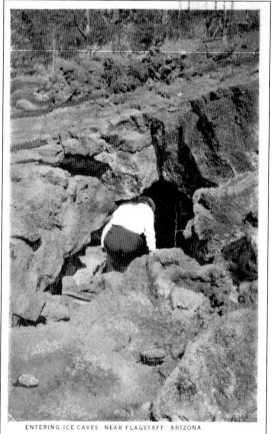

ENTERING ICE CAVES. NEAR FLAGSTAFF. ARIZONA.

WHITE BORDER "PHOSTINT" POSTCARD, 1924 POSTMARK, MADE BY DETROIT PUBLISHING COMPANY. Many people hiked to the top of Sunset Crater to gaze at the San Francisco Peaks and Painted Desert. The Crater Rim Trail was used to access the top of the volcano for a number of years. Due to all the foot traffic, extensive erosion was eating away at the slopes of the crater. It led to the closing of the trail in 1973.

CURT TEICH POSTCARD, 1927 POSTMARK, PUBLISHED BY BABBITT BROTHERS TRADING COMPANY. The reverse reads, "These subterranean passages form a natural refrigerator system and ice is to be found within a short distance from the entrance of the caves at all seasons." The ice cave in the Bonito Lava Flow area of the park was a huge attraction. Not only was it a natural spectacle, but people were said to be taking the ice from the cave and using it for their own personal use.

83. The Devil's Ditch, Sunset Mountain, near Flagstaff, Ariz. Copyright 1906, by A. E. HACKETT.

ABOVE: DIVIDED BACK POSTCARD, 1908 POSTMARK, PUBLISHED BY A. E. HACKETT; RIGHT: UNDIVIDED BACK POSTCARD, PRE-1910S.
Featured in these two postcards are the lava beds that are found at Sunset Crater. The term Devil's Ditch probably referred to the area of the park known today as the Bonito Lava Flow, which streamed out from the west and northwest section of Sunset Crater. It consisted of rough, black lava that covered almost two square miles in the park. It is extremely sharp and difficult to walk on. A feature that might explain the term Devil Ditch are the "squeeze-ups" found in the lava beds. These were created when hot lava was forced up through cracks in the hardened lava crust and cooled to make sharp, rigid slabs that jet out of the flow.

Devils Ditch, Lava Beds, Flagstaff, Ariz.

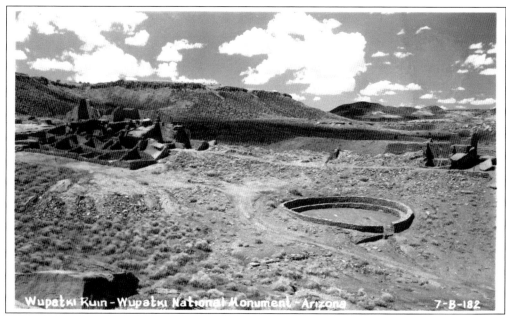

Wupatki Ruin - Wupatki National Monument - Arizona 7-B-182

REAL-PHOTO POSTCARD, C. 1930s–1940s. Pres. Calvin Coolidge created Wupaki National Monument in 1924. In 1937, Pres. Franklin D. Roosevelt added about 34,000 acres to the monument. The ancient people of Wupatki came from all different cultures and areas of the Southwest. The majority were considered to be Anasazi. The Wupatki ruins were a desired location due to their proximity to the Little Colorado River. These structures were made of red Moenkopi sandstone, basalt, and Kaibab limestone.

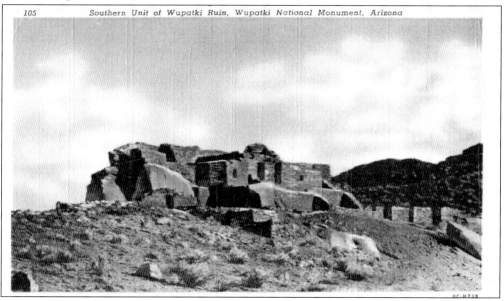

105 Southern Unit of Wupatki Ruin, Wupatki National Monument, Arizona

CURT TEICH LINEN POSTCARD, C. 1930s–1940s. The reverse reads, "The ruins of more than 800 prehistoric home sites have been discovered in Wupatki National Monument, varying from the pits of ancient earth lodges to house structures three stories high, many of which are in an unusual state of preservation. Most accessible are the Citadel and Wupatki, only 5 to 14 miles off US Hwy. 89, just north of Flagstaff."

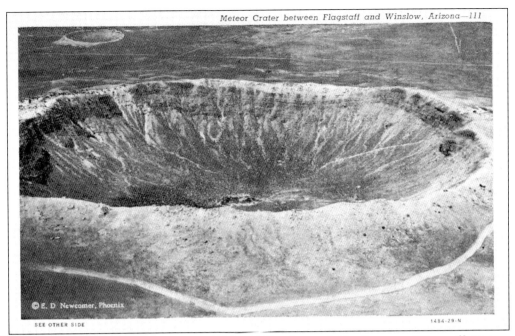

CURT TEICH LINEN POSTCARD, C. 1930s–1940s. Located 43 miles east of Flagstaff, Meteor Crater was the product of a meteorite striking the earth's surface. The crater was initially known as Canyon Diablo Crater. It is also known as the Barringer Crater, for it was Daniel Barringer, in 1903, who first suggested this crater was produced by a meteorite impact.

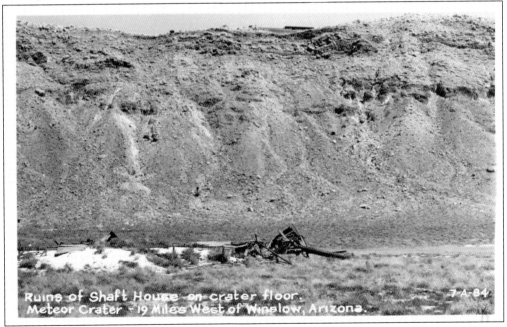

REAL-PHOTO POSTCARD, C. 1930s–1940s. This postcard illustrates the remains of an old shaft-house that was used for mining the remains of the meteorite on the floor of Meteor Crater. Very little of the meteorite was ever discovered there. During the 1960s, NASA astronauts trained on the crater floor to prepare for the Apollo missions to the moon.

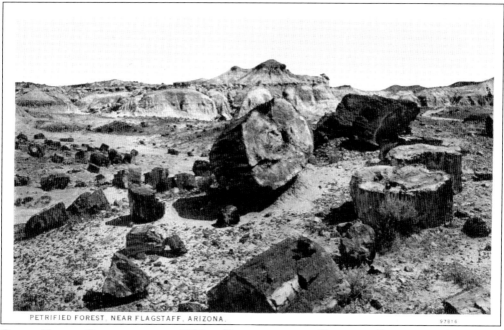

PETRIFIED FOREST, NEAR FLAGSTAFF, ARIZONA.

CURT TEICH POSTCARD, C. 1920S, PUBLISHED BY BABBITT BROTHERS TRADING COMPANY. The Petrified Forest is located a little over 100 miles east of Flagstaff. It's known for its large deposits of petrified wood. This postcard's description reads, "When you arrive in this great Southwest, you realize that the Petrified Forest, about which you studied in school, is indeed a reality."

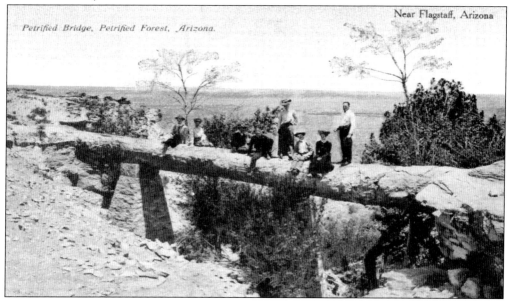

Petrified Bridge, Petrified Forest, Arizona.

Near Flagstaff, Arizona

DIVIDED BACK POSTCARD, C. 1910S. With the Petrified Forest's popularity increasing in the early 1900s, residents of the area were becoming concerned about the tourists and commercial businesses exploiting the petrified wood in the area. The Petrified Forest first became a monument in 1906 when Pres. Theodore Roosevelt signed the Antiquities Act. It was not until 1962 that the monument became a national park.

Eight

SCENIC DRIVES

A MOUNTAIN DRIVE. FLAGSTAFF, ARIZ.

ALBERTYPE POSTCARD, C. 1920S–1930S, PUBLISHED BY THE NEWS STAND. Leisurely drives through the forest were a fun form of entertainment. Many roads leading out of town resembled the one in this postcard. It appears this is the road leading up the hill towards Lowell Observatory. At the top, there is a wonderful view of all of downtown Flagstaff. There are also other roads that head west and have scenic views of the San Francisco Peaks.

REAL-PHOTO POSTCARD, 1929 POSTMARK. John W. Weatherford built the San Francisco Scenic Mountain Boulevard. Initially, it was used as a toll road to access the top of the peaks. Permits were issued in 1916 to build the road, which finally opened in August 1926. Pictured above are the toll house and entry gate. Between the Great Depression of the 1930s and the run of bad luck in Weatherford's life, the idea did not survive. Today, it is a very scenic hiking trail named the Weatherford Trail.

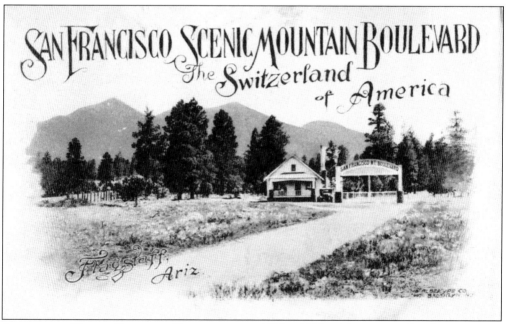

ALBERTYPE HAND-COLORED POSTCARD, C. 1920S–1930S. This postcard is the cover to a souvenir booklet that contains 12 images of the San Francisco Mountain Boulevard. The cover itself is a postcard. Many postcards on the following pages are contained within this booklet. (Courtesy of James E. Babbitt)

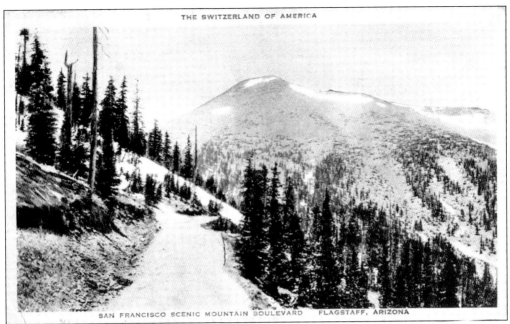

SAN FRANCISCO SCENIC MOUNTAIN BOULEVARD FLAGSTAFF, ARIZONA

ABOVE: ALBERTYPE POSTCARD, 1928 POSTMARK; BELOW: ALBERTYPE HAND-COLORED POSTCARD, C. 1920S–1930S. The San Francisco Mountain Boulevard meandered through the Inner Basin of the Peaks. The road was narrow and steep and would weave back and forth through switchbacks (as shown here). Weatherford's grand scheme was to build a hotel with many amenities on top of Doyle Saddle, but that never happened. In 1926, construction was completed and covered a distance of 10.4 miles up to Fremont Saddle. On August 19, 1926, a "grand opening" event was staged. Approximately 170 automobiles drove up the road for the festivities. The collection of fees for use of the road did not meet expectations. In 1928, his best year, revenues from the toll road added up to $5,000. Admission that year was $2 per car.

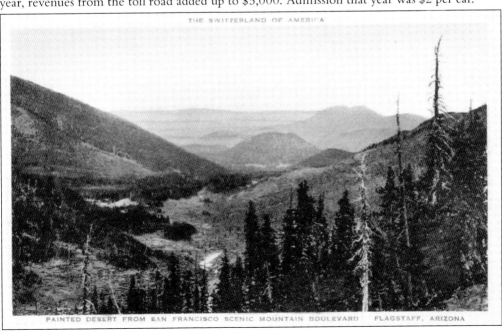

PAINTED DESERT FROM SAN FRANCISCO SCENIC MOUNTAIN BOULEVARD FLAGSTAFF, ARIZONA

109

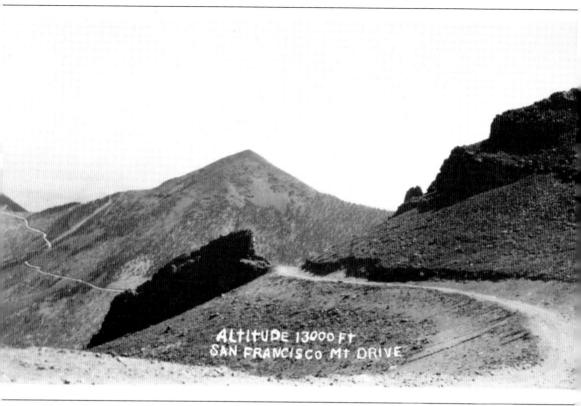

REAL-PHOTO POSTCARD, C. 1930s. The San Francisco Scenic Mountain Boulevard was just one of many entrepreneurial endeavors of John W. Weatherford. As one of Flagstaff's early pioneers, he arrived in the town in 1886 after falling in love with the San Francisco Peaks. He tried his hand in many business ventures, including a saloon. a stage line, and a livery stable. He finally found that selling men's clothing suited him best and did that for 23 years. In 1898, he built a two-story sandstone building on the corner of Leroux Street and Aspen Avenue. He used the lower floor as his mercantile business and lived upstairs with his wife and son, Margaret and Hugh. In March 1899, he began building another structure next door, which would later become the famous Flagstaff landmark, the Weatherford Hotel. The hotel opened its doors on New Year's Day, 1900. In 1910–1911, Weatherford built the Majestic Opera House directly west of his hotel. On New Year's Eve, 1915, the Majestic Opera House collapsed under 61 inches of snow that had accumulated in that week. Weatherford rebuilt the theater much larger than he before and, in August 1917, opened it as the Orpheum Theater. The theater is still in use today.

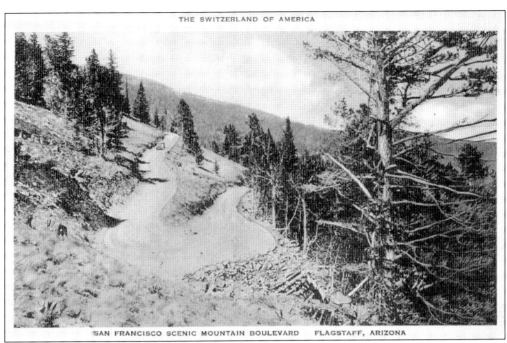

SAN FRANCISCO SCENIC MOUNTAIN BOULEVARD FLAGSTAFF, ARIZONA

ABOVE: ALBERTYPE POSTCARD, C. 1920S–1930S; BELOW: ALBERTYPE POSTCARD, 1930 POSTMARK. The first automobile to arrive in Flagstaff, in 1904, was the property of Dr. John E. Adams. The Babbitts have been selling cars since 1908. Today, they are considered one of the oldest dealerships in the country. As shown in these postcards, cars had to contend with rough roads and broke down frequently. The Model T was the perfect car for this part of the country. For the most part, it was a simple car, easy to repair, did not cost much to operate, and was reasonably priced to purchase. Another unique feature was that it could be jacked up from the rear and used to run machinery if needed.

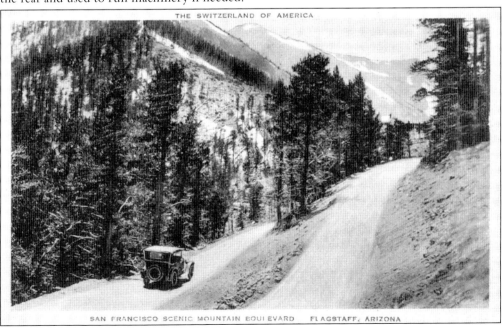

SAN FRANCISCO SCENIC MOUNTAIN BOULEVARD FLAGSTAFF, ARIZONA

SAN FRANCISCO SCENIC MOUNTAIN BOULEVARD FLAGSTAFF, ARIZONA

ABOVE AND BELOW: ALBERTYPE POSTCARD, C. 1920S–1930S. For many years, access to Mount Humphreys using the San Francisco Scenic Mountain Boulevard was only by high clearance, four wheeled vehicles. In 1978, the federal government banned all motorized vehicles from using this trail and others to access the San Francisco Peaks. The area was designated the Kachina Peaks Wilderness Area. Today, this road is still used. It is a very popular hiking trail known as the Weatherford Trail. Another feature still in use is the Toll House. It is a private residence and has been renovated a few times.

SAN FRANCISCO SCENIC MOUNTAINBOULEVARD FLAGSTAFF, ARIZONA

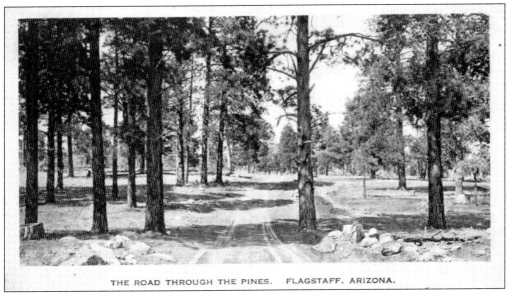

THE ROAD THROUGH THE PINES. FLAGSTAFF, ARIZONA.

ALBERTYPE POSTCARD, C. 1920S–1930S, PUBLISHED BY THE NEWS STAND. Written on the back is: "Todo arbol es Madera pero el pino no es caoba. Spanish Proverb. All trees are wood but the pine is no mahogany." The Coconino Experiment Station, known today as the Fort Valley Experimental Forest, was the first US Forest Service research facility. It opened in August 1908 as an outdoor laboratory to determine the forest's health in this area. Many Flagstaff lumbermen were worried about why the ponderosa pine forest was not regenerating after being logged.

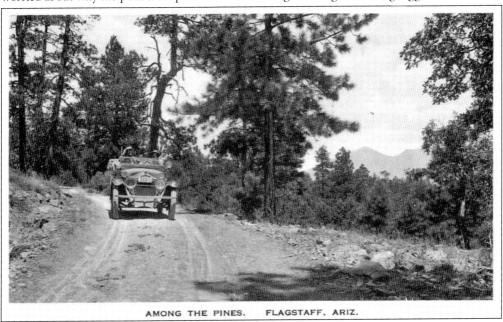

AMONG THE PINES. FLAGSTAFF, ARIZ.

ALBERTYPE POSTCARD, C. 1920S–1930S, PUBLISHED BY THE NEWS STAND. Many of the dirt roads surrounding Flagstaff were built for reasons other than leisure, such as harvesting timber, controlling livestock, and accessing forest fires. Many roads were built from fees collected by the Forest Service. In 1906, the Forest Service began to impose a charge for the use of the National Forests. It would return some of the money to the states to help build and improve roads.

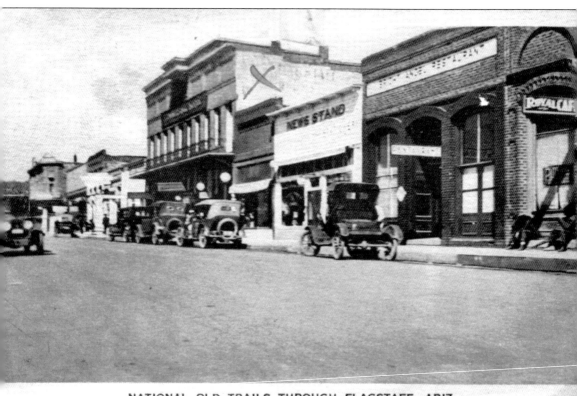

NATIONAL OLD TRAILS THROUGH FLAGSTAFF, ARIZ.

ALBERTYPE POSTCARD, 1924 POSTMARK. With the rise of tourism and automobile traffic through Flagstaff, new roads were needed. Flagstaff became a major crossroads for travelers in this part of the Arizona Territory. The east-west corridor followed the Beale Wagon Road, which later was named the National Old Trails Highway in 1912. The National Old Trails Highway Association was formed to promote the first highway to connect Baltimore and Los Angeles. In 1920, Flagstaff's City Council decided to pave almost two miles of Railroad Avenue to serve as part of the Old Trails Highway. Part of this road is displayed in the postcard above. In the following years, the accelerated growth of automobile ownership and increased tourism led to many new businesses sprouting up, particularly in the lodging industry.

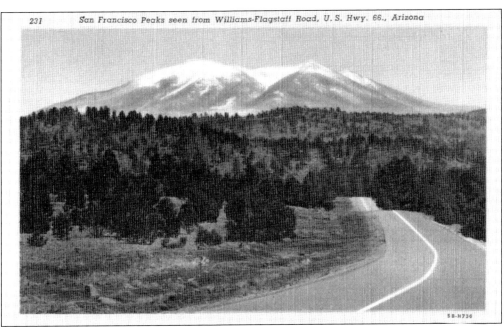

San Francisco Peaks seen from Williams-Flagstaff Road, U. S. Hwy. 66., Arizona

5B-H736

ABOVE: CURT TEICH LINEN POSTCARD, C. 1940s–1950s; BELOW: REAL-PHOTO POSTCARD, C. 1940s. In 1926, US Highway 66 was labeled as a major highway from Chicago to Los Angeles. This led to the renaming of the National Old Trails Highway to Route 66 across Arizona. Nicknamed "The Mother Road," many people found themselves taking vacations and leisurely drives along this highway. By the late 1950s, almost 50 motels were in operation along Route 66 within Flagstaff's city limits. The completion of Interstate 40 south of Route 66 made the city very nervous about its economic situation. On October 1, 1968, construction was finished on I-40 around the city. This made Flagstaff the first Arizona city on Route 66 to be bypassed. Many businesses suffered and dissolved because of this. As of today, only about half of the original motels remain functional.

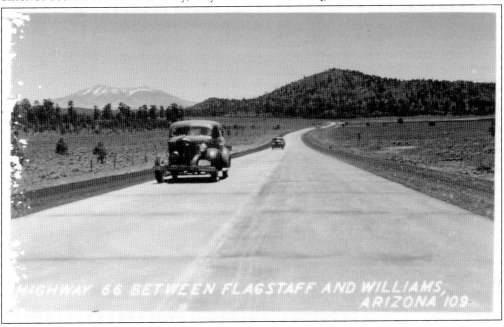

HIGHWAY 66 BETWEEN FLAGSTAFF AND WILLIAMS, ARIZONA 109

REAL-PHOTO POSTCARD, C. 1940S.
This postcard shows a dirt road entering town from the south, most likely on US 89A. The letter on the reverse states, "Dear Mother and Dad and all, I haven't heard from you in a long time. Wish I could be up there. I sure hope your Alfalfa does good. I have 15 acres. It just went to seed. I lost all the first bunch of blossoms but still have a good crop of the second blums. We have had a lot of good weather so far this summer, a few hot days. You will see me one of these days. I hope. Ed."

REAL-PHOTO POSTCARD, C. 1940S.
This postcard shows the road heading up Snowbowl Road. The Civilian Conservation Corps was instrumental in building the road. The CCC was created in 1933 as a result of the Great Depression. Part of Franklin D. Roosevelt's New Deal, it provided jobs to single young men in need. These men worked in forests and parks and helped make improvements such as building roads and structures.

Nine

LAYOVERS

LINEN POSTCARD, 1956 POSTMARK, A "COLOURPICTURE" PUBLICATION. The 66 Motel was built in 1945 and was operated by owner Myron Wells. In the late 1950s, it was owned and operated by Mr. and Mrs. L.G. Toothaker. It boasted 15 modern units with steam heat, wall-to-wall carpeting, and kitchenettes: "The Best in the West for Your Money."

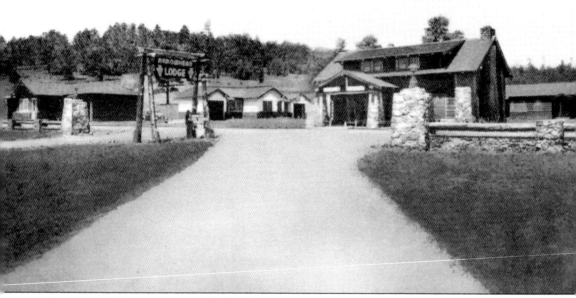

ALBERTYPE POSTCARD, C. 1940S. Motor courts or motor inns were quite common along Route 66. There were many similar traits these motels possessed. Many would have built-in garages, steam heat, and kitchenettes. Often the owners would have their residences on the premises, usually next to the office. Another feature that was often present was neon signs. Neon was first used for advertising in the United States in 1923. One of Route 66's lasting images was of the neon signs businesses often used. The Arrowhead Lodge was built in 1937 for owner R.J. Behymer. A few years later, the motel was sold to the Gobles. In the 1950s, the name changed to the Gaslite Motel, and then in the 1960s it changed again to the Twilight Motel. Today, it has reverted back to the name Arrowhead Lodge. This postcard boasts, "Flagstaff's Finest Hotel Court."

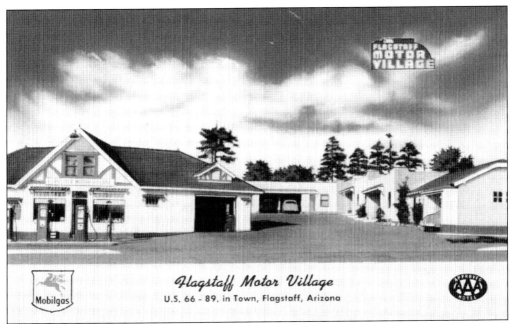

LINEN ADVERTISING POSTCARD, C. 1950S. Flagstaff Motor Village was located on Route 66 on the eastern edge of downtown. On the property was a Mobilgas Service Station. The Babbitt family owned the motel. It consisted of 17 units with private garages. Today, the property is a used car lot.

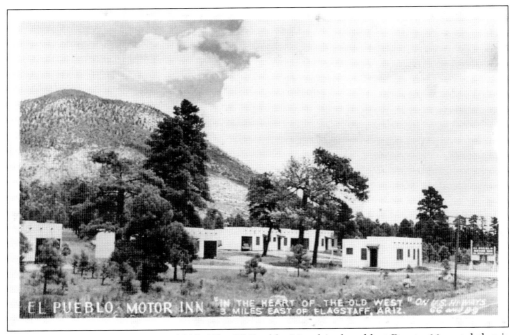

REAL-PHOTO POSTCARD, C. 1940. The El Pueblo Motel is the oldest Route 66 motel that is not immediately in the downtown area. Philip Johnston built it in 1936. He was best known for recruiting and training the first Navajo Code Talkers during World War II. The motel proclaims to be "A Home Away From Home. Modern Comfort in the Pines. In the Heart of the Old West."

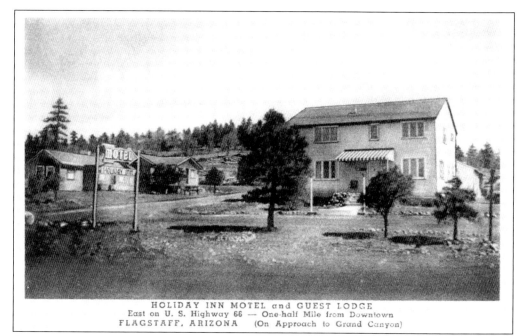

HOLIDAY INN MOTEL and GUEST LODGE
East on U. S. Highway 66 — One-half Mile from Downtown
FLAGSTAFF, ARIZONA (On Approach to Grand Canyon)

ALBERTYPE ADVERTISING POSTCARD, C. 1940s–1950s. The Holiday Inn Motel and Guest Lodge was located a half mile from downtown. It was advertised as "A Modern Motel of Deluxe Brick Units. Cool in summer and with Panel Ray heat for winter comfort. Hardwood Floors. Featuring finest quality Serta springs and mattresses." This motel had no relation to the popular Holiday Inn chain of today.

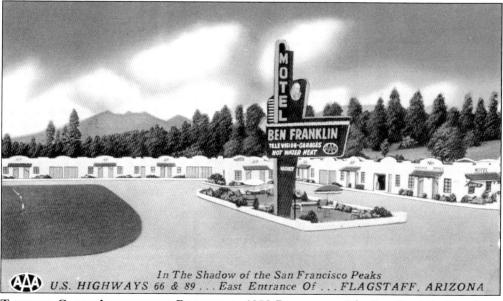

In The Shadow of the San Francisco Peaks
U.S. HIGHWAYS 66 & 89 . . . East Entrance Of . . . FLAGSTAFF, ARIZONA

TICHNOR GLOSS ADVERTISING POSTCARD, 1958 POSTMARK. The Ben Franklin Motel was initially owned by Earl Tinnin. On the back of the postcard is the following: "For those who care, ceramic tiled baths . . . radiant and hot water heat thermostat individually controlled . . . T.V. and radios in rooms . . . enclosed garages . . . air conditioned by nature . . . Mr. and Mrs. Ray A. Young, Owners and Operators."

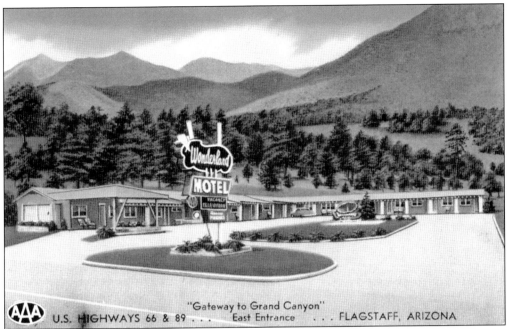

Tichnor Gloss Advertising Postcard, c. 1950s–1960s. The Wonderland Motel was built in 1956. It was owned by T.E. Hanshaw and later changed hands to Waldo and Adelyne Spelta. The postcard boasts, "Natures Air conditioning . . . Immaculately styled and furnished . . . Simmons Beauty Rest Mattresses . . . Motel with the View . . . Flagstaff's Newest and Finest."

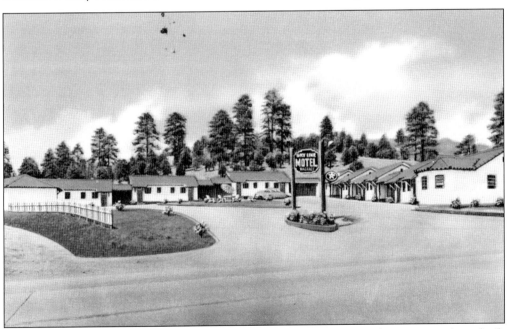

Tichnor Gloss Advertising Postcard, c. 1950s–1960s. The Sky Line Motel was built in 1952 and was run by Don Nicholson. The postcard states, "In the shadow of the San Francisco Peaks, Eastern Gateway to Grand Canyon . . . Air Conditioned by nature. Owner: Mr. and Mrs. Fred G. Long." The motel was renamed the Red Rose and is still in existence today.

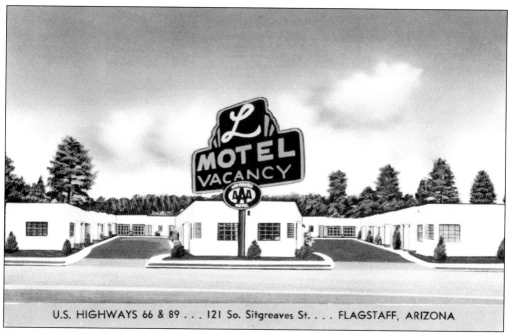

U.S. HIGHWAYS 66 & 89 . . . 121 So. Sitgreaves St. FLAGSTAFF, ARIZONA

TICHNOR GLOSS ADVERTISING POSTCARD, C. 1950S–1960S. The L Motel was built in 1949 along Route 66 and South Sitgreaves Street (now Milton Road). The postcard mentions "15 new, fully modern, insulated units . . . close to business district . . . Mr. and Mrs. Luther L. Jones Owners and Operators." In the early 1960s, it was run by Mr. and Mrs. Alvin A. Arnsten.

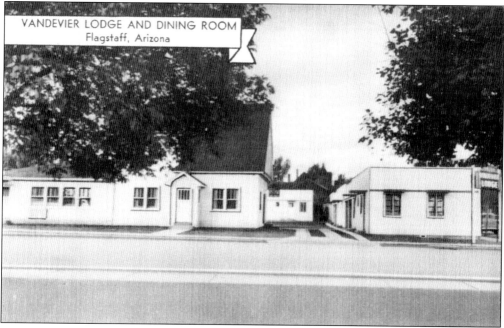

LINEN ADVERTISING POSTCARD, C. 1940S–1950S. The Vandevier Lodge and Dining Room was opened in 1941 by Arthur Vandevier. The popular dining room was run by his wife, Laura. Arthur Vandevier worked for the sheriff's department and was very involved with local politics. The motel was torn down in 1977, and now apartments occupy this area.

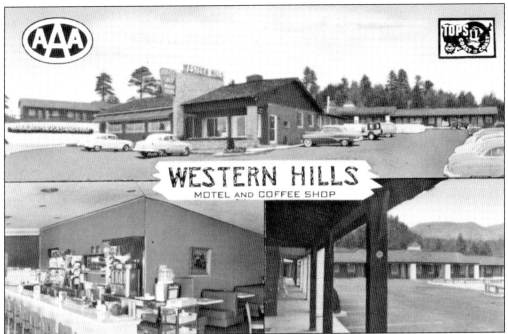

ABOVE: LINEN POSTCARD, C. 1950S; BELOW: LINEN ADVERTISING POSTCARD, C. 1950S.
The Western Hills Motel was built in 1951 by Harold Melville. There were originally 29 units in the motel. The ownership changed hands to Charles Greening in 1954. The office/manager's residence occupied the same building as the coffee shop. The neon sign in front of the motel is the oldest of its kind in Flagstaff. The postcard advertises "29 beautifully furnished units with phones and piped Music in rooms. Radiant water heat, all-glass showers and tubs, wall to wall carpets. Owner-operated restaurant specializing in Eastern Prime rib and steaks. Patio and playground." This motel is still in operation today.

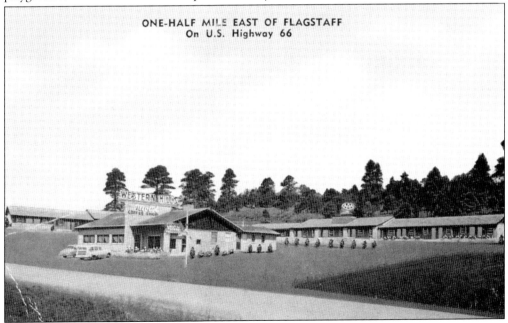

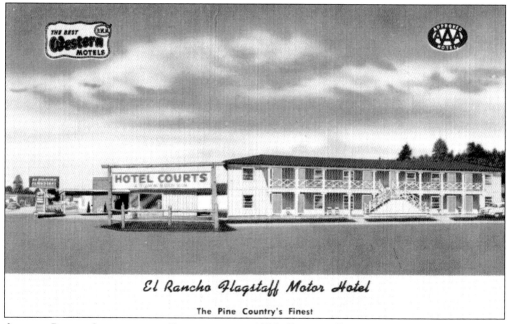

El Rancho Flagstaff Motor Hotel

The Pine Country's Finest

ABOVE: LINEN ADVERTISING POSTCARD, C. 1950; BELOW: PHOTOCHROME ADVERTISING POSTCARD, C. 1960S. The El Rancho Flagstaff Motor Hotel was located on West Route 66. It was run by R.C. Stewart and later sold to G.H. Perkins. The postcard reads, "Enjoy Western hospitality at its best . . . at the Pine Country's finest hotel court. No railroad noise . . . 55 ultra–modern units, located at 7000 ft. elevation. Air-conditioned by nature in summer . . . Individually controlled heat for your comfort in winter." Flamingo Hotels bought the El Rancho in 1954. They added to the structure and created the Flamingo Motor Hotel. In 1959, the Flamingo turned into the Ramada Inn. Flagstaff can boast of being the first town to have a Ramada Inn.

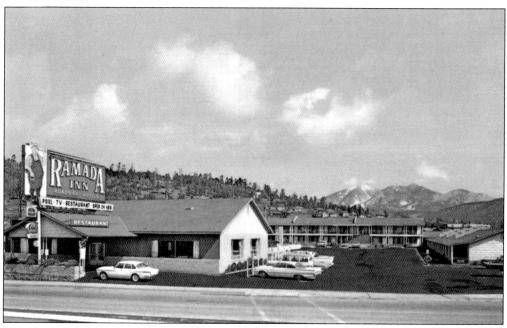

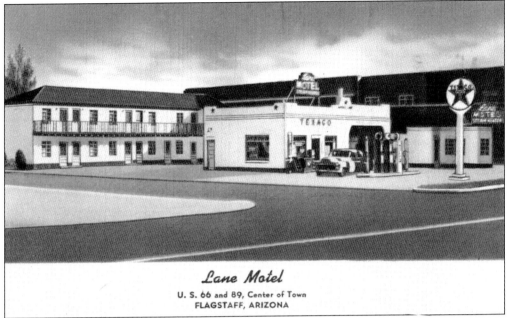

Lane Motel

U. S. 66 and 89, Center of Town
FLAGSTAFF, ARIZONA

LINEN ADVERTISING POSTCARD, C. 1950S. The Lane Motel opened for business in 1948 on Route 66 and Humphreys Street and was owned by Joe Sharber and Haydee Lane. There was a Texaco Service Station located on the property. The postcard mentions the convenience of "complete 24-hour one-stop Texaco Service while you sleep." The motel has had many names in recent history but is still in operation, minus the service station.

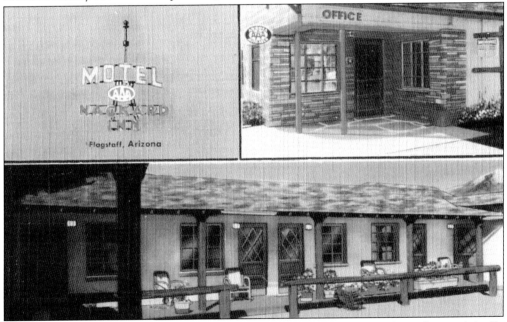

LINEN ADVERTISING POSTCARD, C. 1950S. The Nackard Inn Motel and Hotel was originally built in 1929 by K.J. Nackard. It later became known as the Nackard's Downtowner Motel in 1950. The establishment is located one block south of Route 66 on San Francisco Street in downtown Flagstaff. It contained 50 "modern motel-hotel" units.

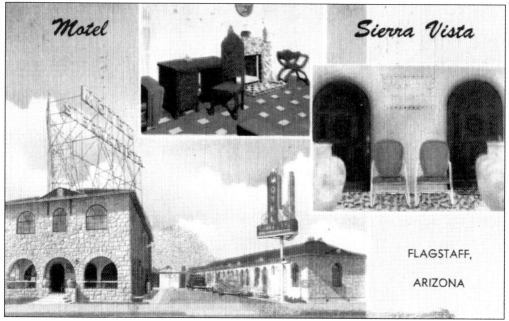

LINEN POSTCARD, 1952 POSTMARK. The Sierra Vista Motel was built in 1937 by Salvador Esparza. This postcard advertises: "Every room with steam heat and private baths. Enclosed steam heated garages. Clean, beautiful rooms bursting with Spanish charm and Western hospitality. Hand Painted tiles, pictures, imported hand carved doors and desk. Very picturesque." The hotel was used as apartments beginning in the mid-1960s.

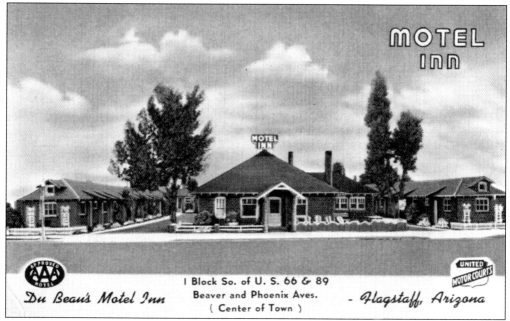

LINEN POSTCARD, C. 1940S–1950S. The Du Beau's Motel Inn was built by A.N. Du Beau in 1929. The motel is considered to be the first Flagstaff motel. It originally housed 23 "fully modern, fire-proof units with private tile baths." Located one block south of Route 66 in downtown Flagstaff, today it is used as a hostel.

BIBLIOGRAPHY

Audretsch, Robert W. "Phantom Ranch: Crucible of the Conservation Corps." *The Journal of Arizona History.* Vol. 52, Number 1 (Spring 2011): 31–52.

Babbitt, James E. "The Impassible Dream: John W. Weatherford's San Francisco Mountain Boulevard." *The Journal of Arizona History.* Vol. 47, Number 2 (Summer 2006): 173–184.

Babbitt, John G. *The Babbitt Brothers Trading Company: An Address before the Newcomen Society.* Babbitt Brothers Trading Co., 1967.

Cline, Platt. *Mountain Town: Flagstaff's First Century.* Flagstaff, AZ: Northland Press, 1994.

———. *They Came to the Mountain: The Story of Flagstaff's Beginnings.* Flagstaff, AZ: Northland Press, 1976.

Drickamer, Lee C. and Peter J. Runge. *Northern Arizona University: Buildings as History.* Tucson, AZ: The University of Arizona Press, 2011.

Houk, Rose. *From the Hill: The History of Lowell Observatory.* 2nd edition, Lowell Observatory, 2000.

———. *Sunset Crater Volcano National Monument.* Tuscon, AZ: Southwest Parks and Monuments Association. 1995.

Jackson, Jane E. "Lake Placid of the West: A History of Early Skiing in Flagstaff." *The Journal of Arizona History.* Vol. 50, Number 3 (Autumn 2009): 205–236.

Kupel, Douglas, E. "A Place of Our Own: Fort Tuthill and the Arizona National Guard." *The Journal of Arizona History.* Vol. 48, Number 2 (Summer 2007): 153–176.

Lamb, Susan. *Wupatki National Monument.* Tucson, AZ: Southwest Parks and Monuments Association. 1999.

Mangum, Richard K. and Sherry G. Mangum. *Flagstaff Album: Flagstaff's First Fifty Years in Photographs, 1876–1926.* Flagstaff, AZ: Hexagon Press. 1993.

———. *Flagstaff: Past and Present.* Flagstaff, AZ: Northland Publishing. 2003.

Thybony, Scott. *Walnut Canyon National Monument.* Tucson, AZ: Western National Parks Association, 2006.

United States Department of the Interior, National Park Service. *National Register of Historic Places.* 2005.

www.arcadiapublishing.com

Discover books about the town where you grew up, the cities where your friends and families live, the town where your parents met, or even that retirement spot you've been dreaming about. Our Web site provides history lovers with exclusive deals, advanced notification about new titles, e-mail alerts of author events, and much more.

Arcadia Publishing, the leading local history publisher in the United States, is committed to making history accessible and meaningful through publishing books that celebrate and preserve the heritage of America's people and places. Consistent with our mission to preserve history on a local level, this book was printed in South Carolina on American-made paper and manufactured entirely in the United States.

This book carries the accredited Forest Stewardship Council (FSC) label and is printed on 100 percent FSC-certified paper. Products carrying the FSC label are independently certified to assure consumers that they come from forests that are managed to meet the social, economic, and ecological needs of present and future generations.

FSC
Mixed Sources
Product group from well-managed
forests and other controlled sources

Cert no. SW-COC-001530
www.fsc.org
© 1996 Forest Stewardship Council

Find Your Place in History.